AMERICAN VOYAGE

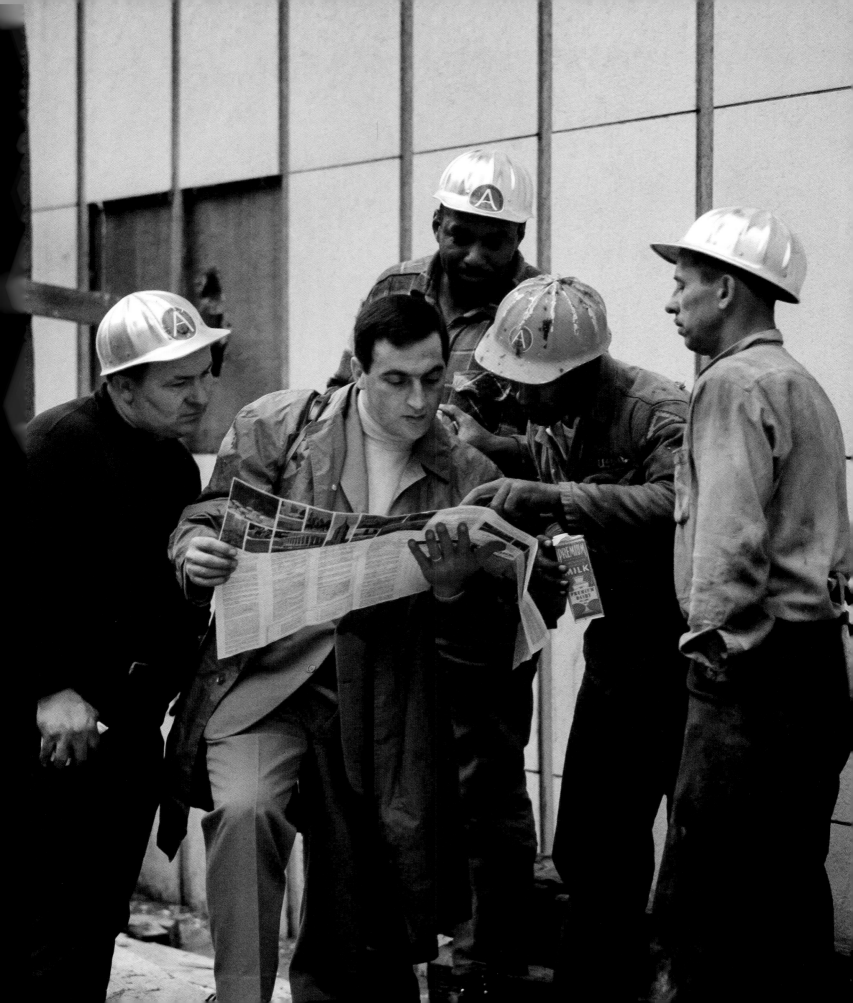

AMERICAN VOYAGE

Photographs By Mario Carnicelli

REEL ART PRESS

DAVID HILL GALLERY

For Nicla and Chiara

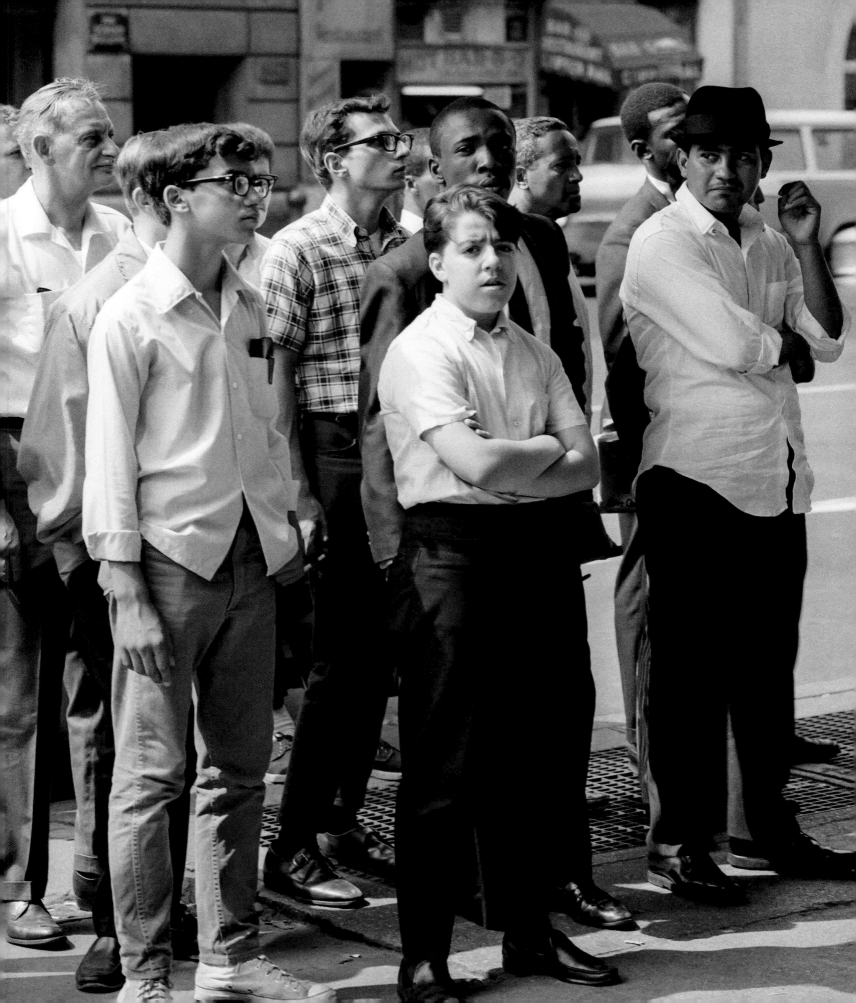

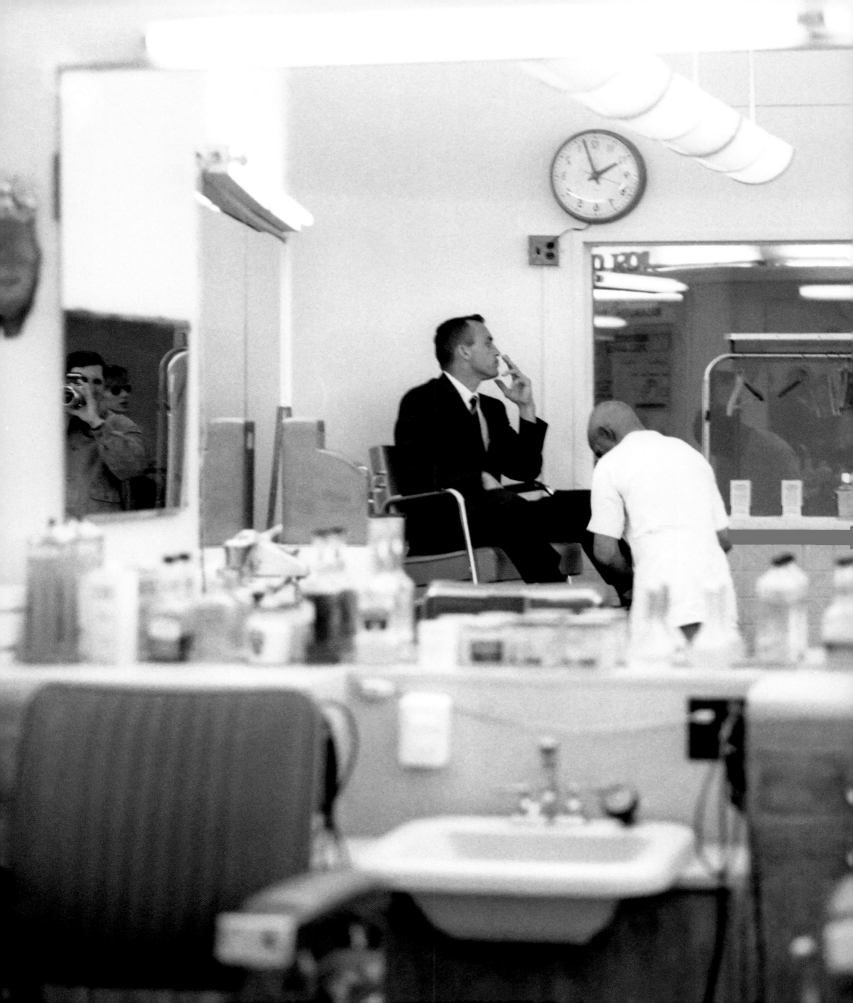

If Mario Carnicelli hadn't closed his photography store in 2010 and asked me to have a look at his old negatives I would never have known, like many of us, that he was a photographer. In his cellar lay a hidden treasure, a foreign and fascinating world in black and white but also in exquisite colour, hundreds of stories and microstories of the sixties and seventies mostly set in Italy, but also in America.

Once we started curating and scanning the archive of carelessly stored medium format and 35mm negatives, the nostalgic vintage flavour made way for the discovery of an astonishingly modern attitude, beauty without rhetoric, ordinary gestures that become iconic, centered on his interest in exploring the human condition of individuals in different societies. His archive comprises a cohesive body of documentary work of thousands of images, that after fifty years finally gets the attention it deserves.

BÄRBEL REINHARD

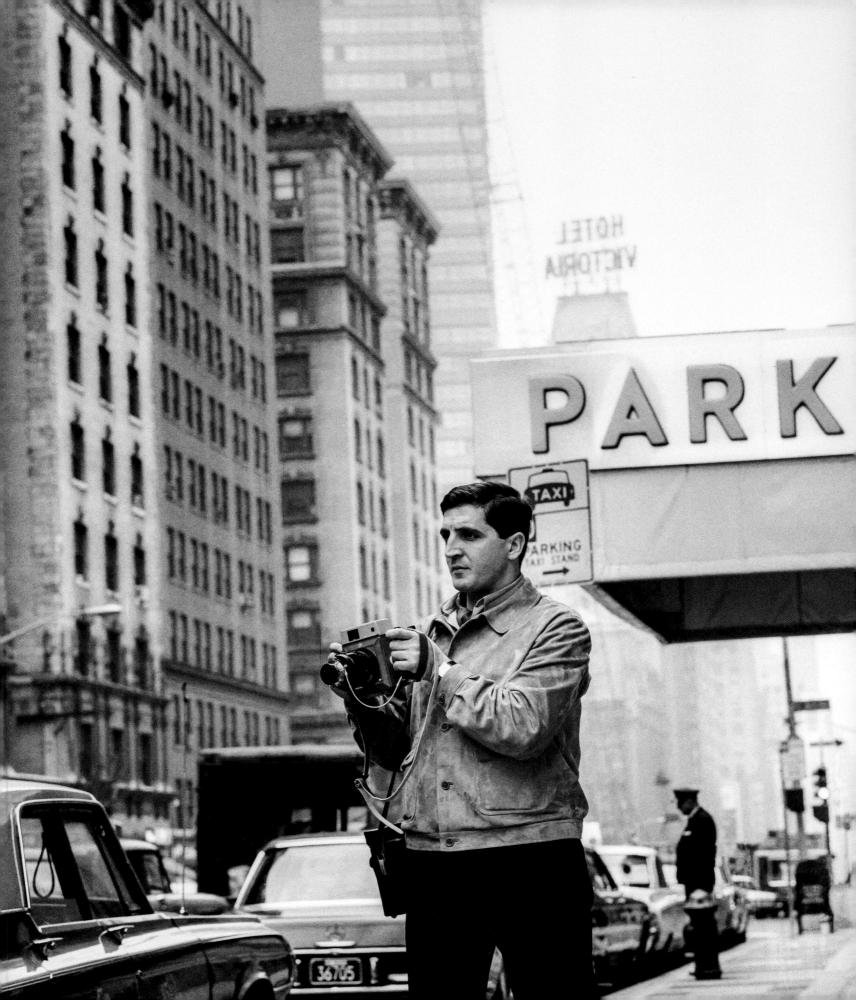

Bärbel Reinhard called me to consult and help her plan ways of showcasing the newly rediscovered work of Mario Carnicelli. When I first saw his photographs, especially the contacts of his American Voyage, I was completely surprised by how modern his images were, especially in colour, and with an almost un-Italian gaze. They did not compare to any other work done in the same period in Italy.

A peculiar characteristic of Carnicelli's modernity lies in what he defines as an approach of normality versus his subjects, registering what he finds in front of his camera, without intervening. An atypical attitude for a kind of photography that at the time was still looking for artistic authoritativeness in the decisive moment and in composition. Mario Carnicelli comes to attention not only in the history of Italian photography but also internationally, precisely for the modality and the era in which he worked.

MARCO SIGNORINI

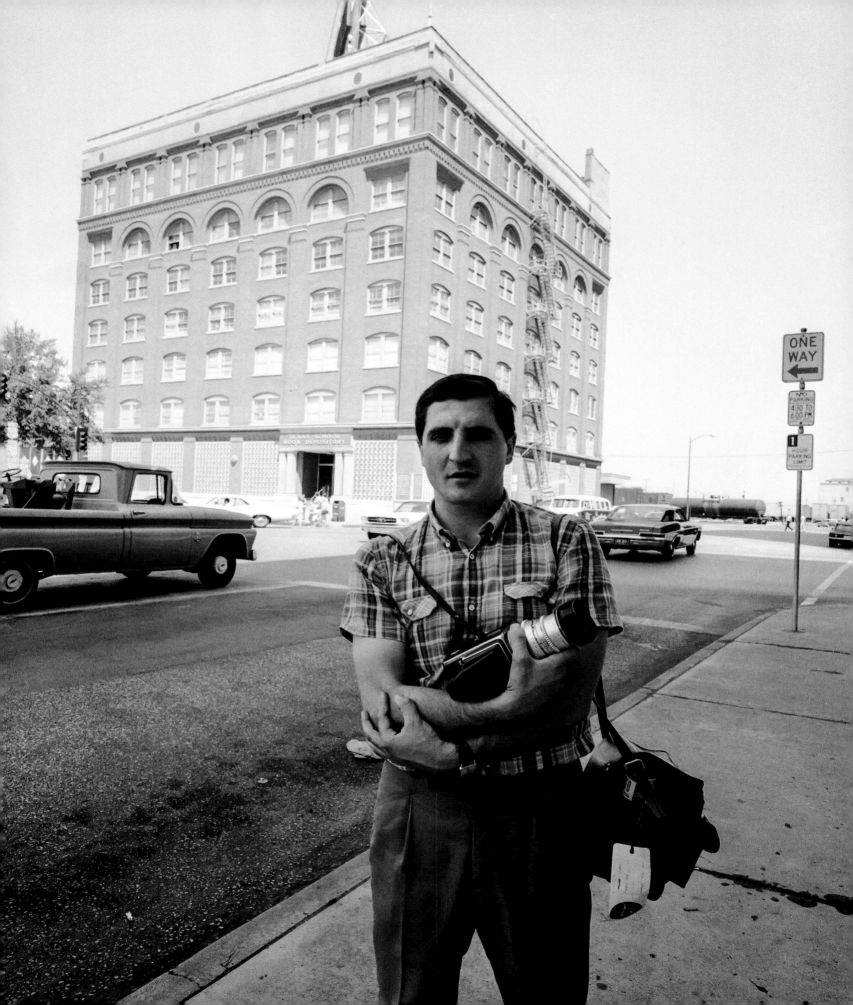

Photography is my way of writing, my language. My main subject is always the person, the humanity. Man is never alone, he is the crowd and the crowd becomes man. People narrate their selves through their gaze, their clothes, their way of moving. You understand immediately where they come from and where they are going. Images come to me as if they were looking for me, they don't need footnotes, just references: place and date. It's in this precise moment that an image becomes a photograph.

MARIO CARNICELLI

In 1966, Mario Carnicelli—at the time a young documentary photographer from Tuscany—won first place in a national Italian photography competition sponsored by *Popular Photography* magazine, Ferrania Film, Mamiya and Pentax. On submitting an image of a demonstration in his hometown of Pistoia, Tuscany, Carnicelli won a scholarship to photograph America. He left Europe for the first time and embarked on a one month trip to the States, his American Voyage. This was followed by more trips over the next few years, and time spent in cities including Detroit, Washington, D.C., San Francisco, Buffalo, New York and Chicago.

Carnicelli was attracted by the carefree liberty, the happy-go-lucky spirit of American society and was overwhelmed by its diversity, mix of cultures, traditions, ways of life, and by the extroverted fashion and individualism. Seen through the prism of his own Italian heritage—a homogenous national identity tied to an idea of collective membership and strong familial bonds—he perceived the complexity of the melting pot of American society with an alert and acute gaze. America was more than another continent, another part of the world; America was a state of mind, a passion, a restless fever. Everything was possible and everything could change from one moment to the next.

The photographs that Carnicelli brought back from his first trip were showcased in an exhibition at the Pirelli Tower in Milan under the rather curious title, *I'm sorry, America!* Carnicelli was apologizing for the lens of an outsider, presenting everyday life in America from an inquisitive and very personal point of view. He felt almost like an intruder in a society completely new to him. With no preconceptions of the American Dream, his work also revealed its contradictions, loneliness and its insurmountable class and social divisions. This deep and fundamental fascination brought him back to the States over the next few years, always with an anthropological focus, interested in ordinary people, in everyday life.

In Carnicelli's work as a freelance photojournalist he also travelled to other countries, working on both commissions and personal projects. In the early 1970s, however, he renounced this career to follow in the footsteps of the family business as a dealer of photographic equipment, opening a renowned developing and printing service in Florence.

The regret of having abandoned his vocation was always with Carnicelli. He was again *sorry, America!*, this time for giving up on his photographic vision, his lost dream; for having forgotten thousands of negatives in a box in the cellar for over fifty years.

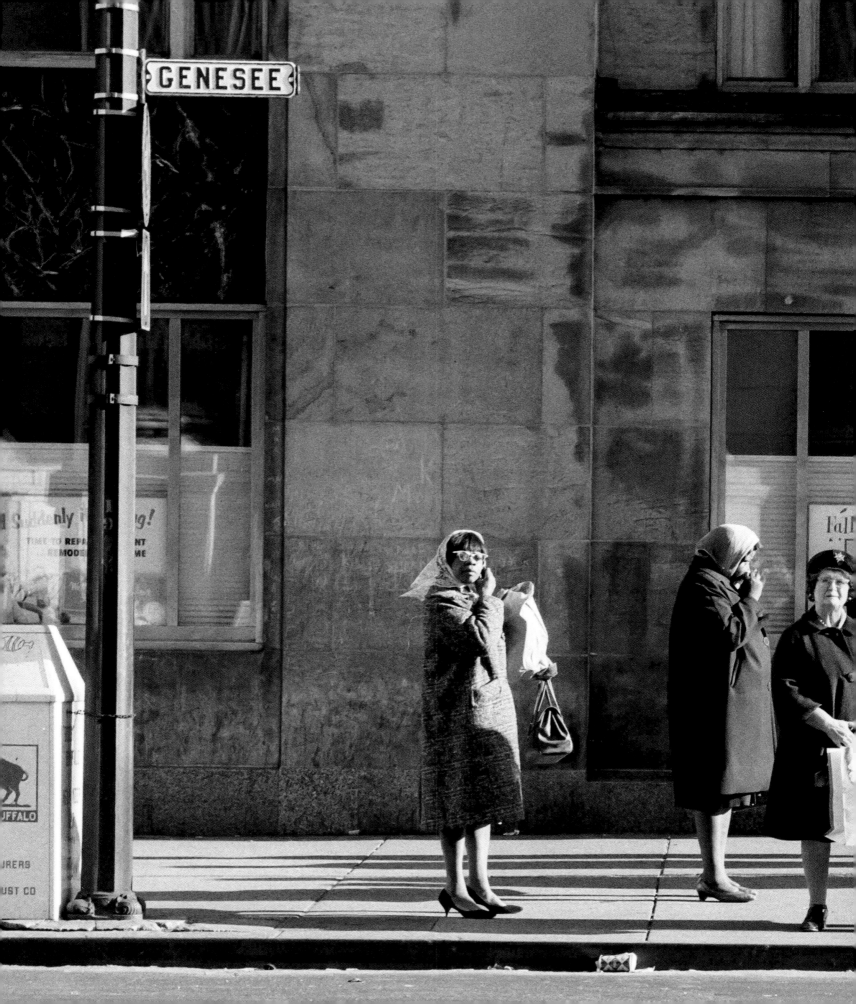

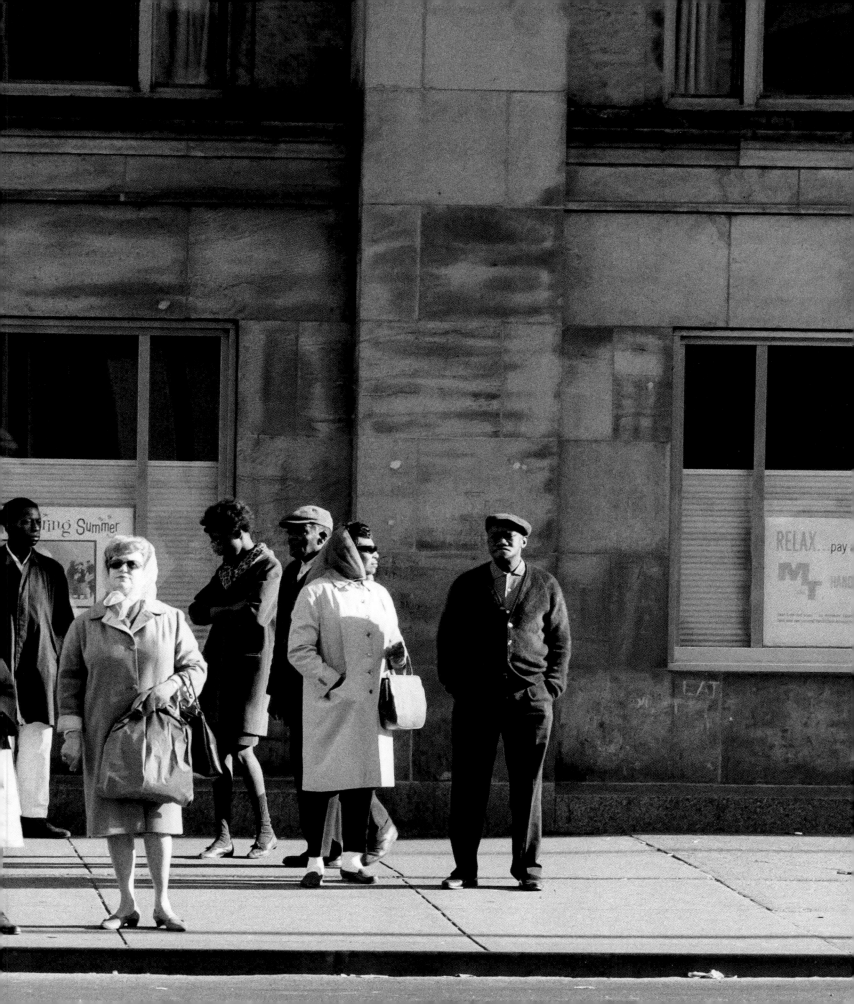

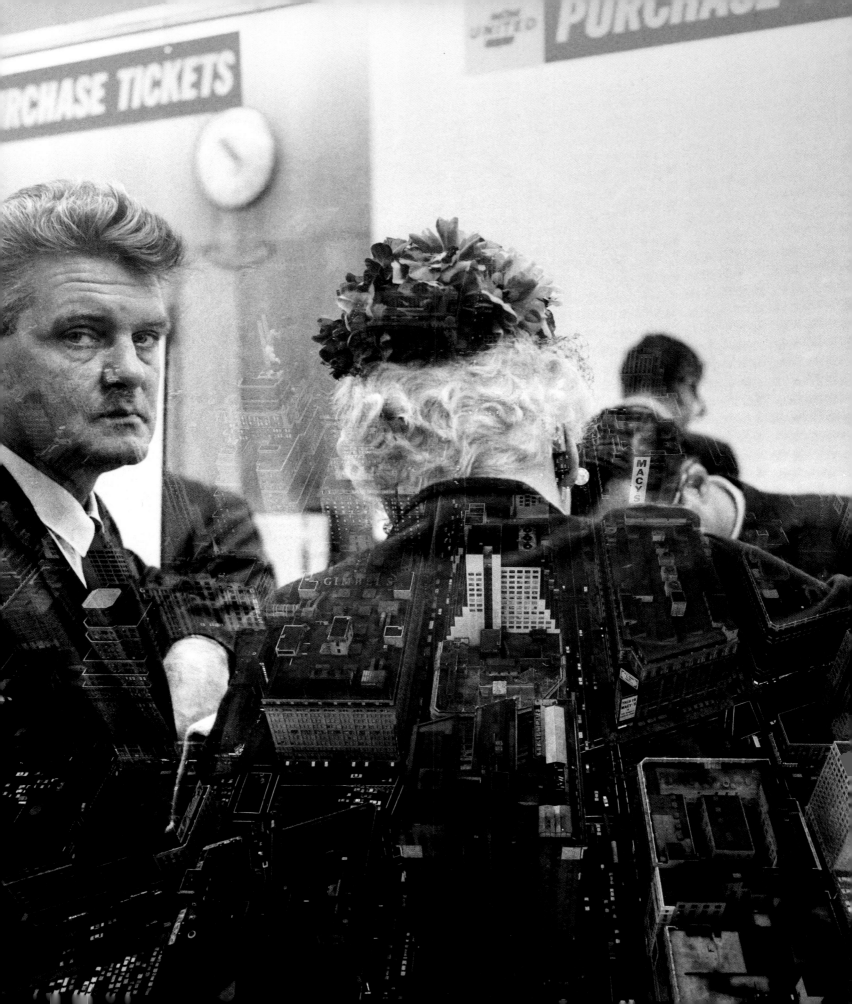

AMERICAN VOYAGE

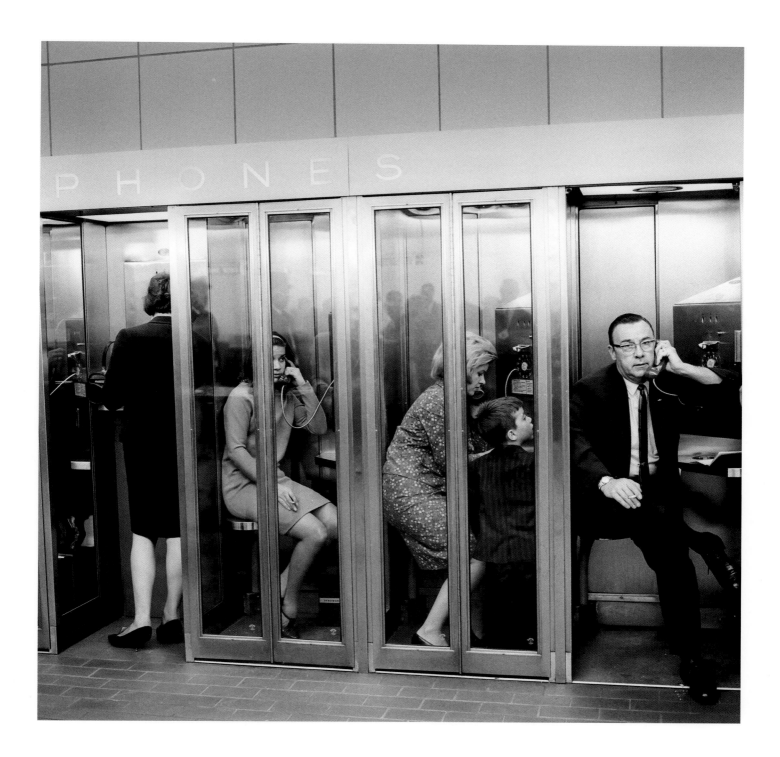

Telephone booths, O'Hare International Airport, Chicago, 1966

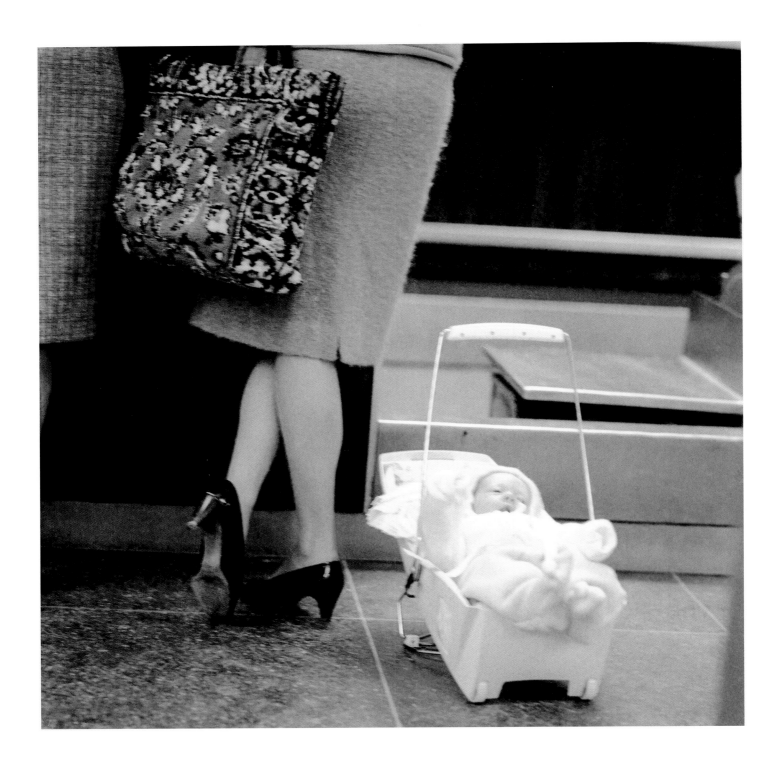

Check-in counter, O'Hare International Airport, Chicago, 1966

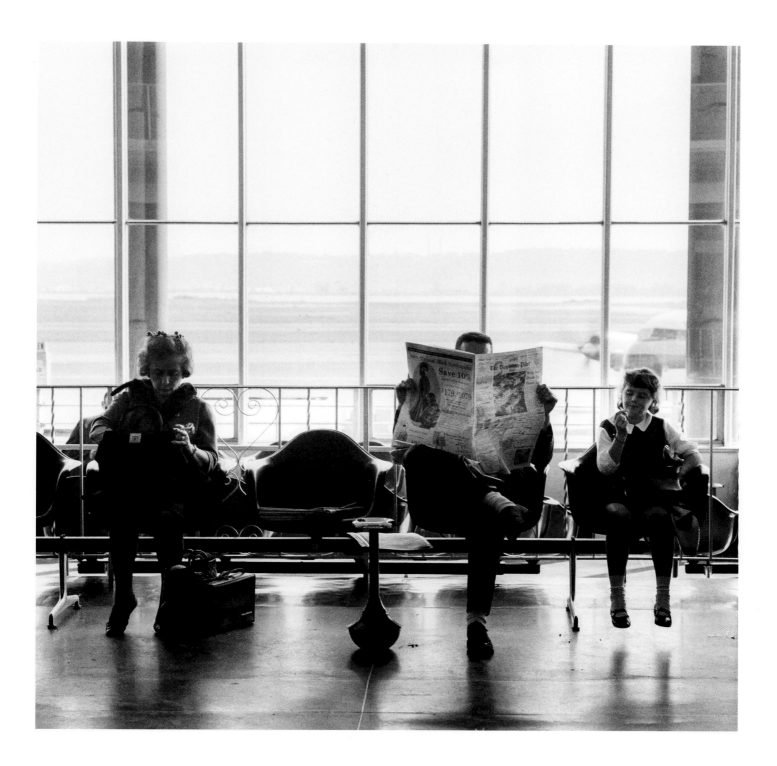

Passengers, O'Hare International Airport, Chicago, 1966

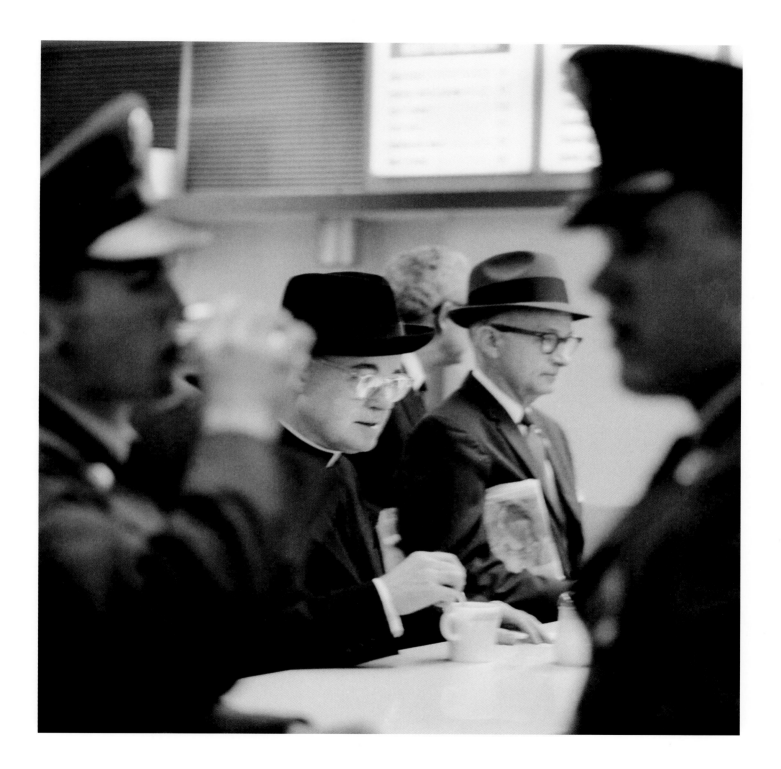

Cafeteria counter, O'Hare International Airport, Chicago, 1966

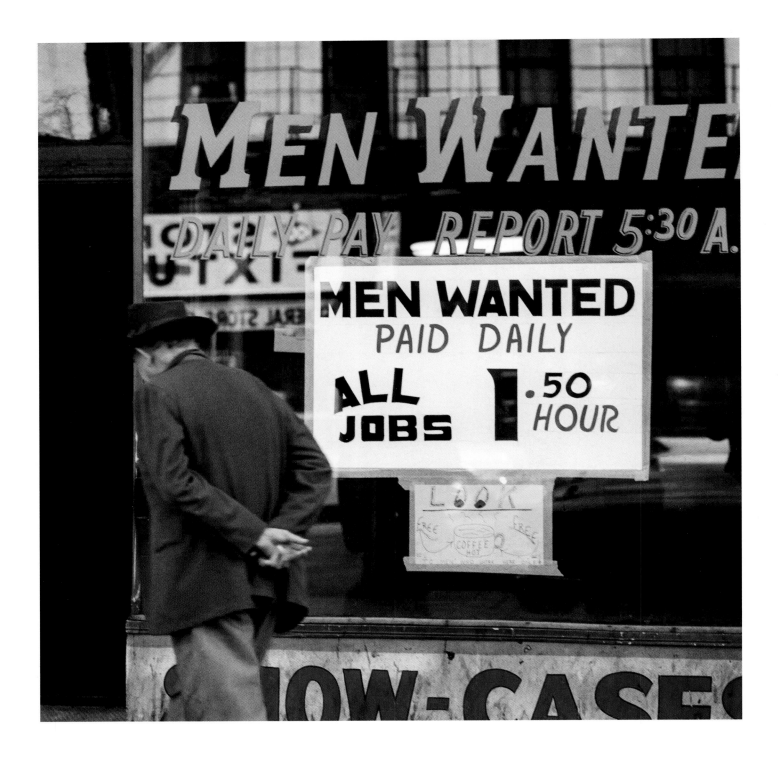

Job centre, Chicago, 1966

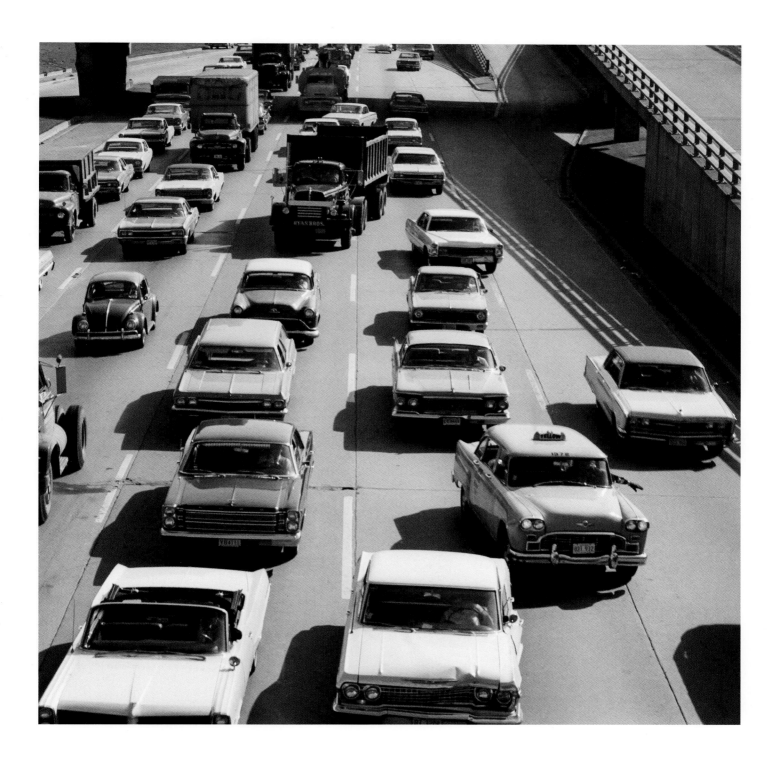

Yellow cab, Chicago, 1966

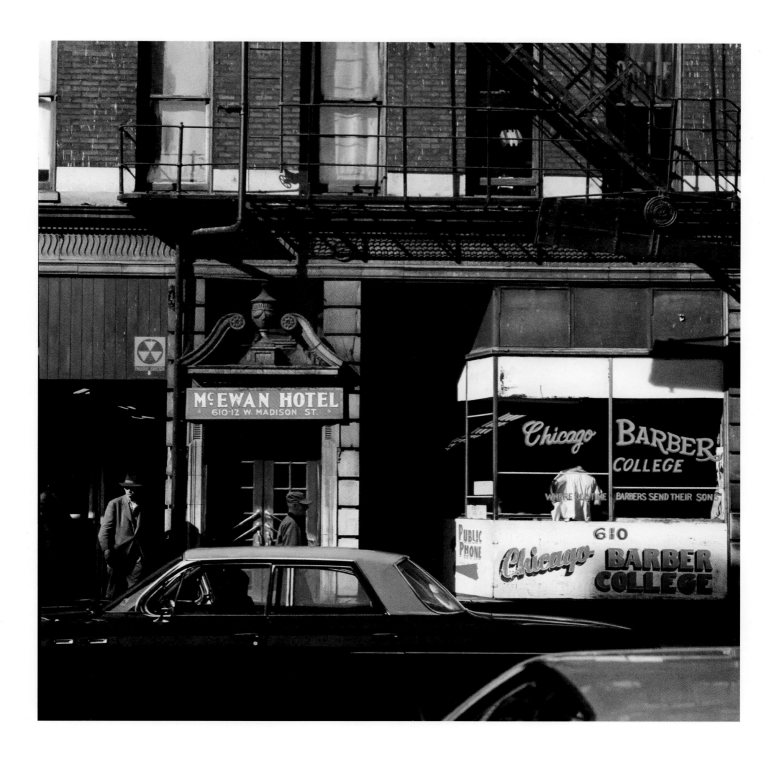

Barber College, Chicago, 1966

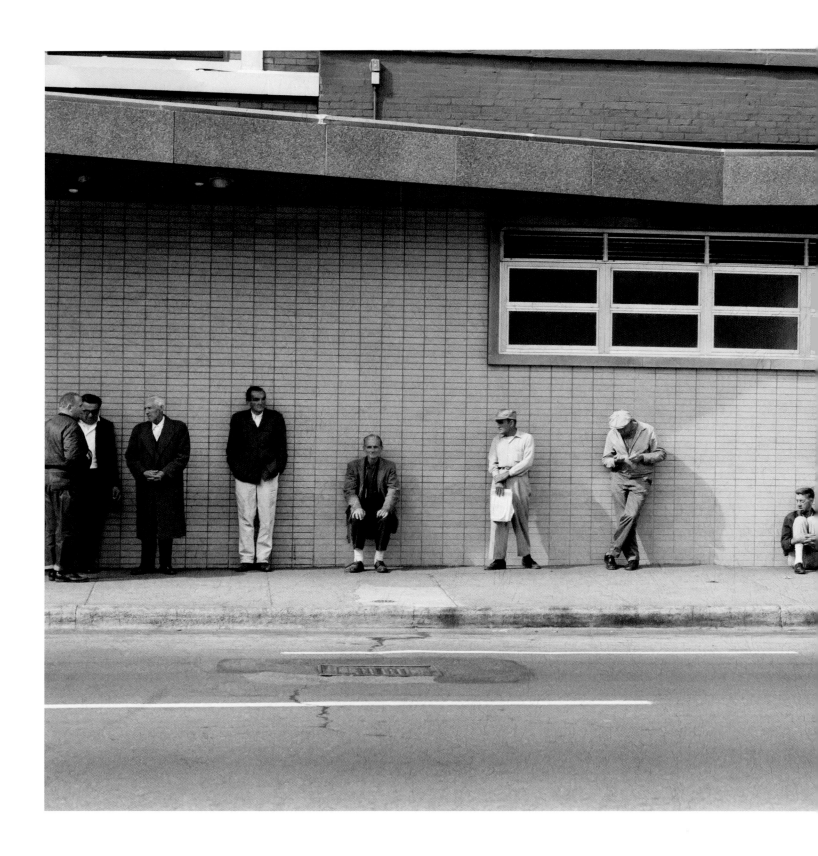

Job centre line, Chicago, 1966

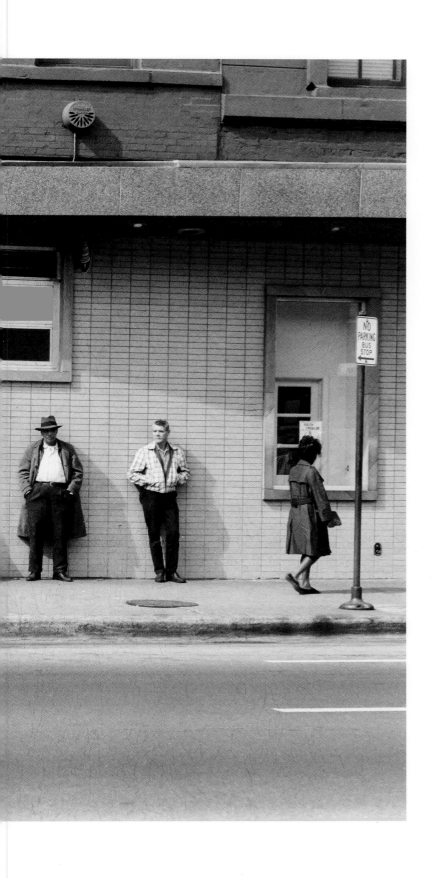

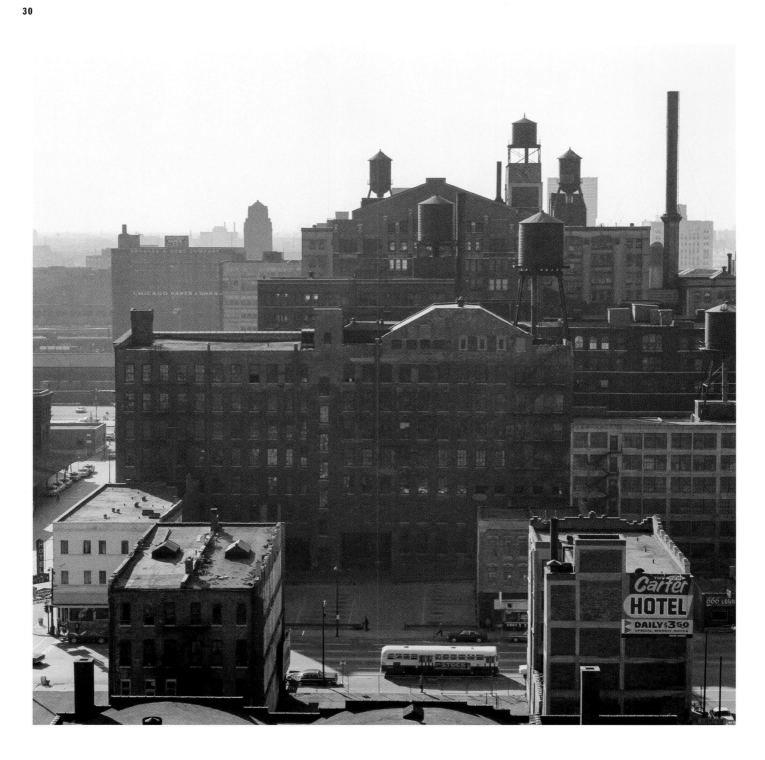

Factories, Chicago, 1966

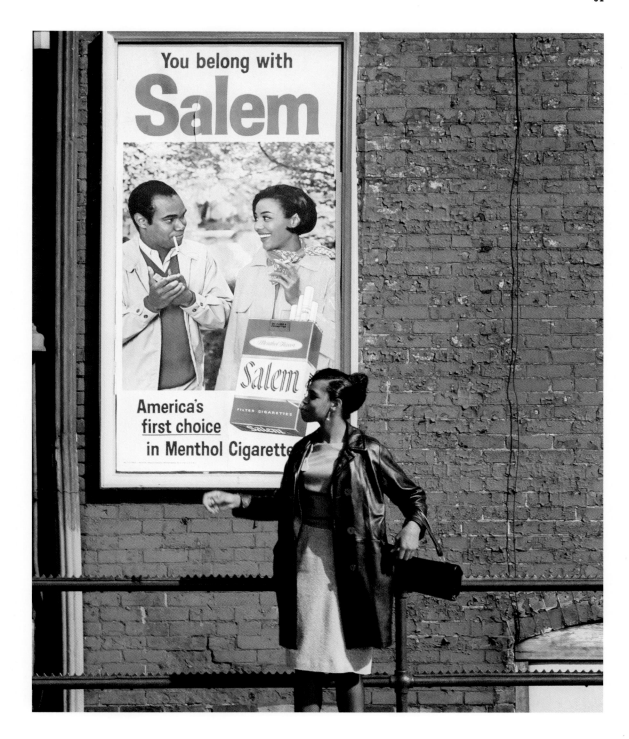

Salem cigarettes billboard, Chicago, 1966

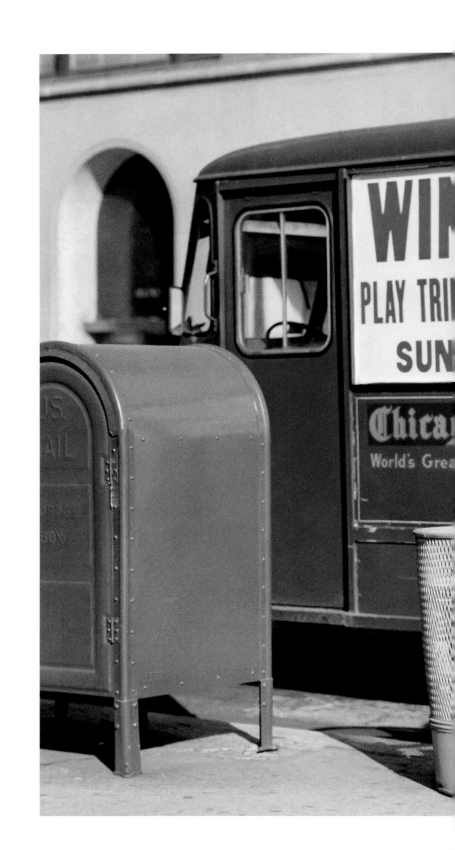

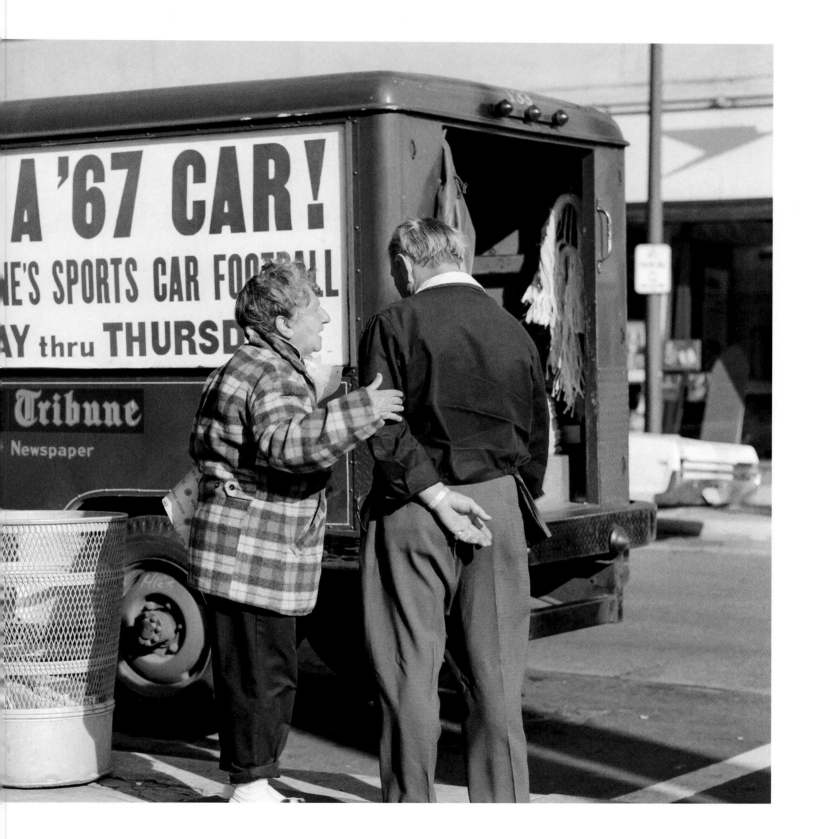

Win A '67 Car!, Chicago, 1966

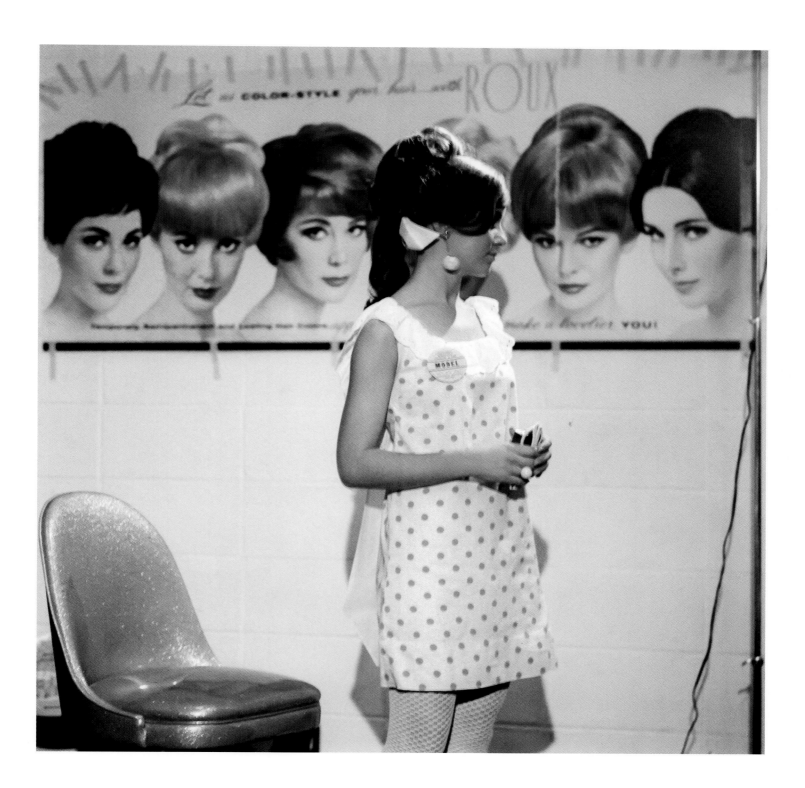

Model at hairdresser convention, Chicago, 1966

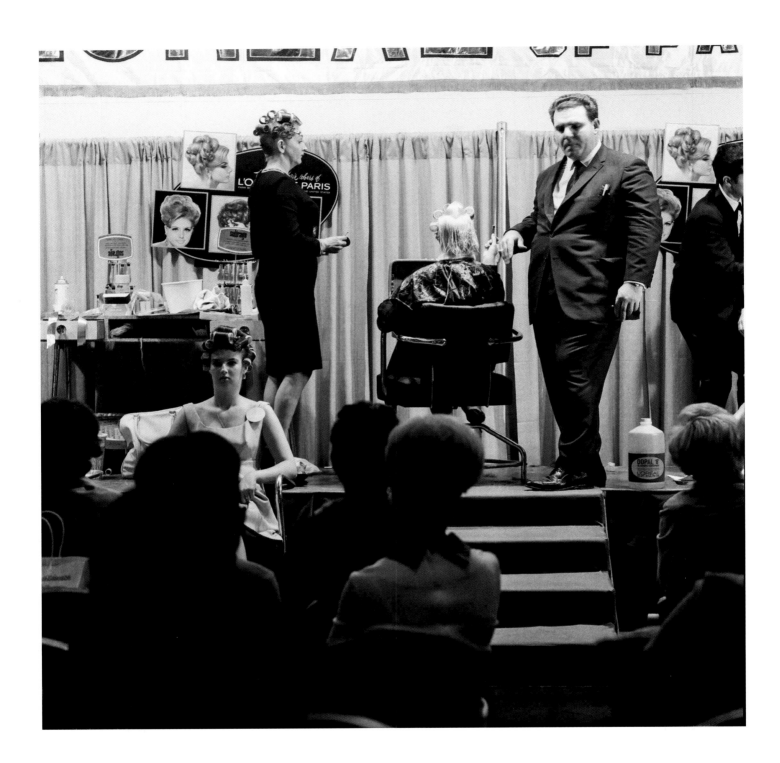

Hairdresser convention, Chicago, 1966

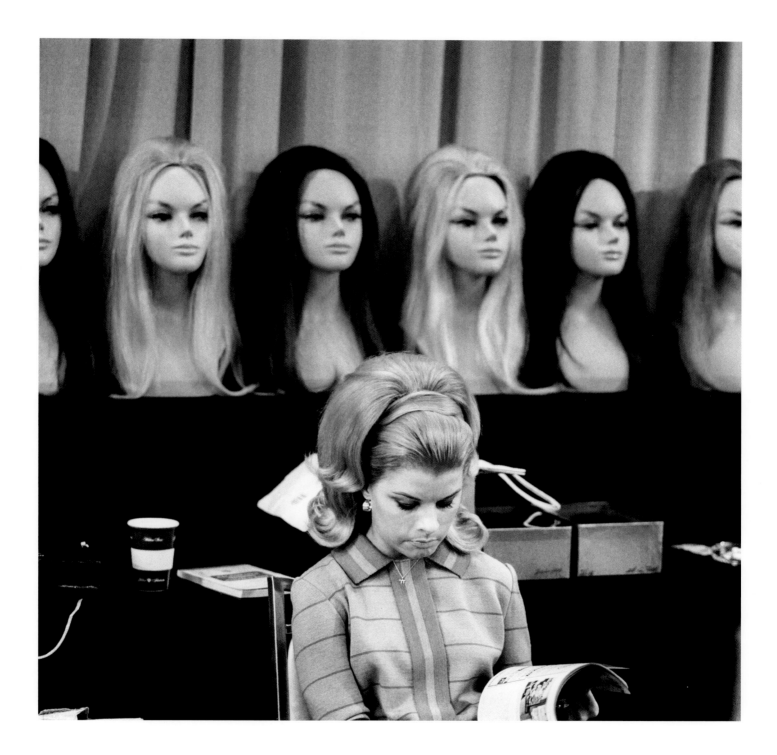

Wig stand, Chicago, 1966

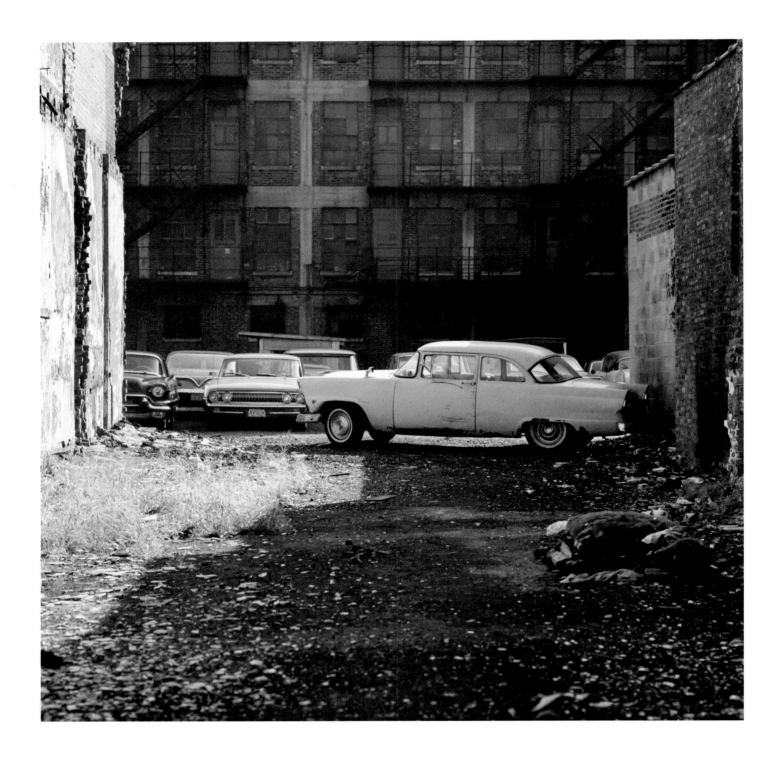

Green 1955 Ford, Chicago, 1966

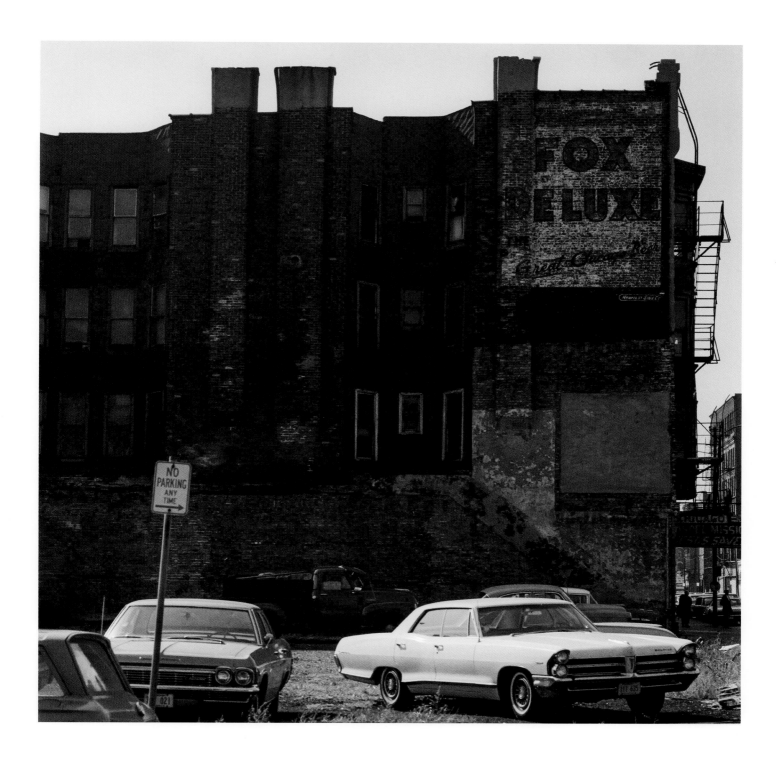

No Parking, Chicago, 1966

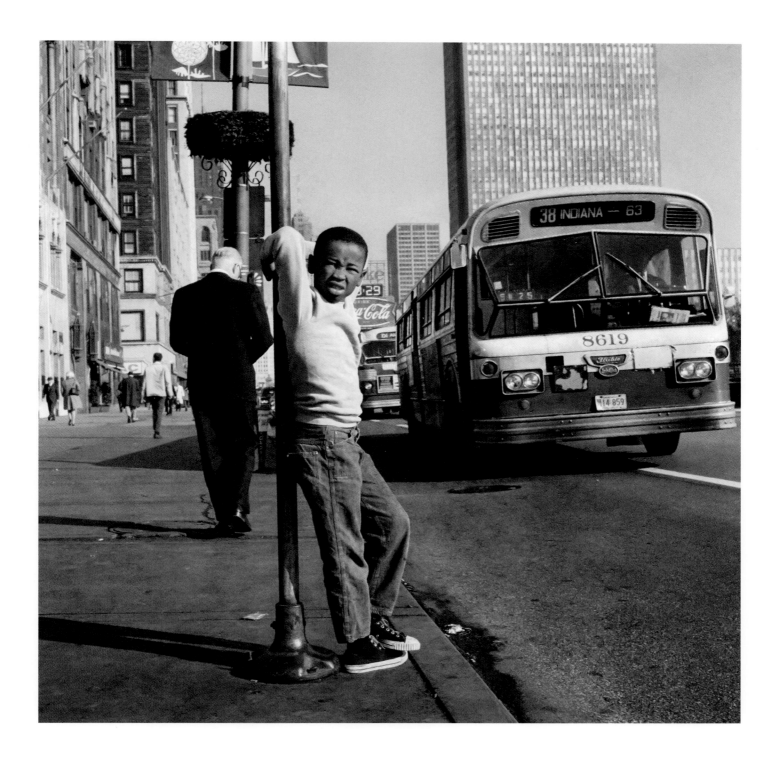

Bus to Indiana, Chicago, 1966

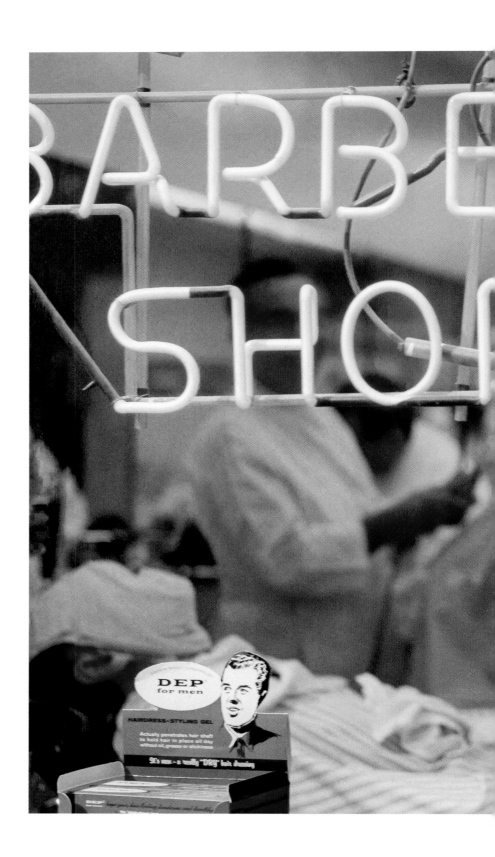

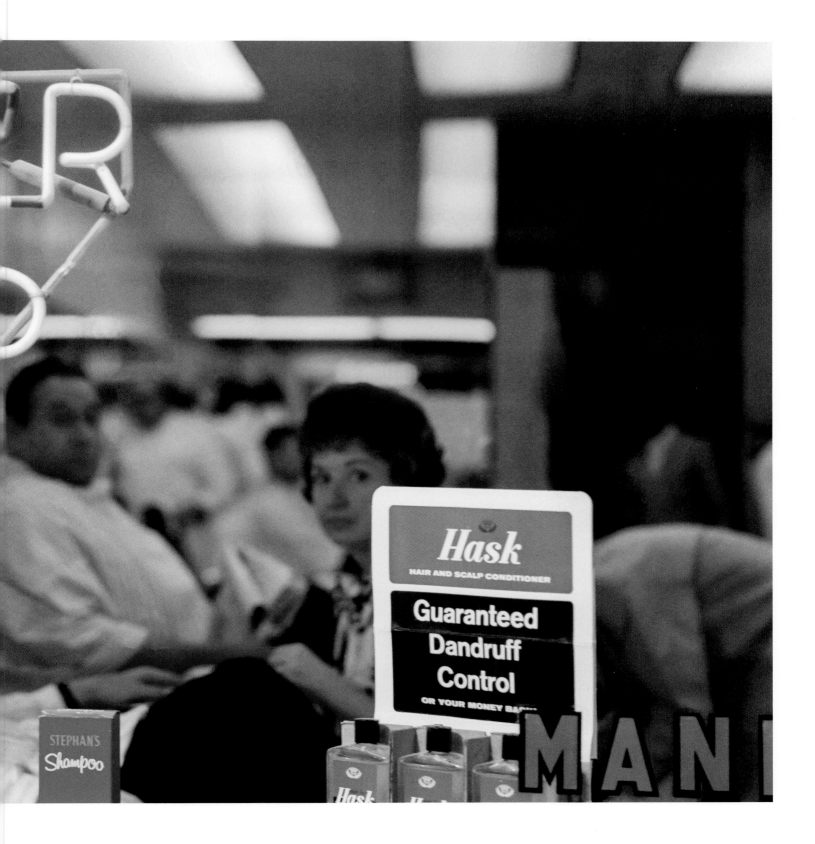

Barber shop neon, Chicago, 1966

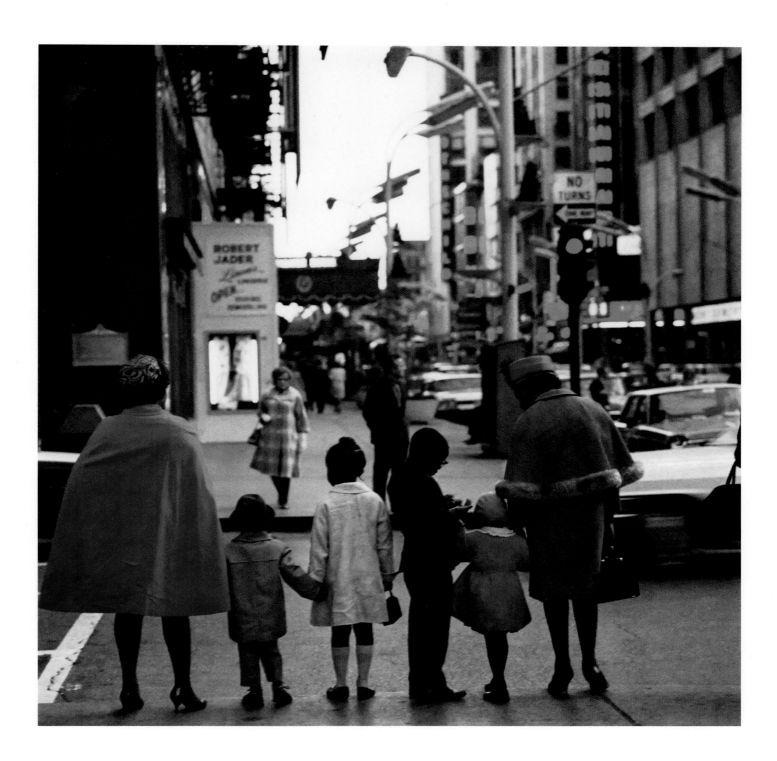

Red lights, Chicago, 1966

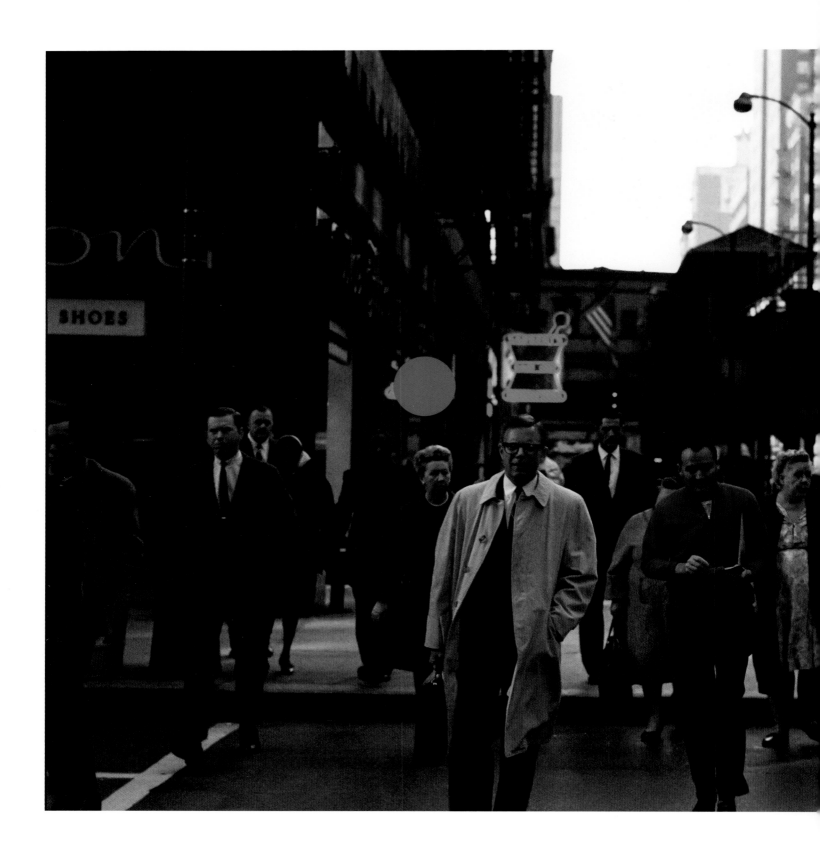

After work, Chicago, 1966

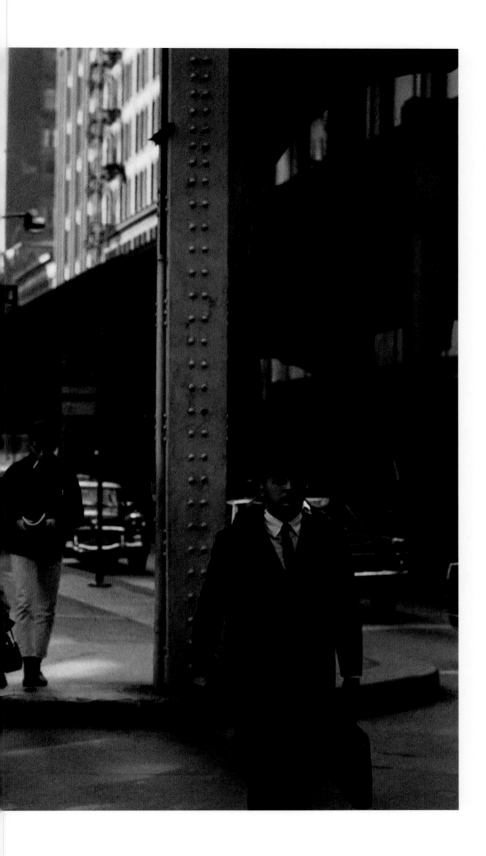

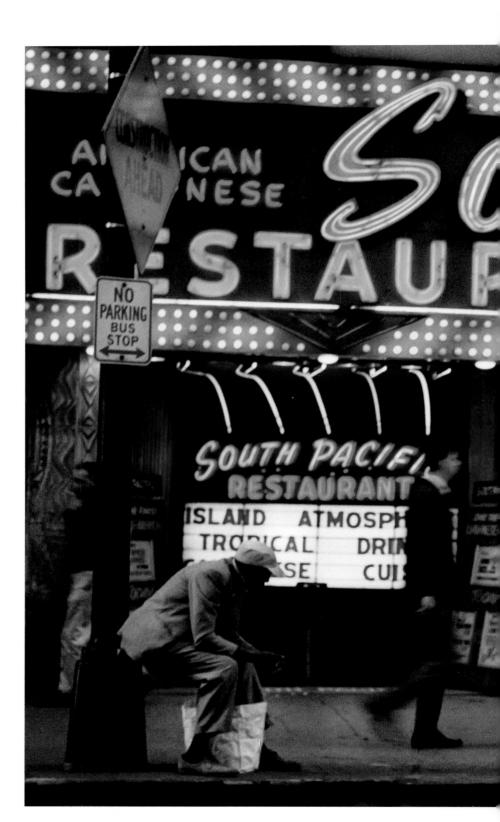

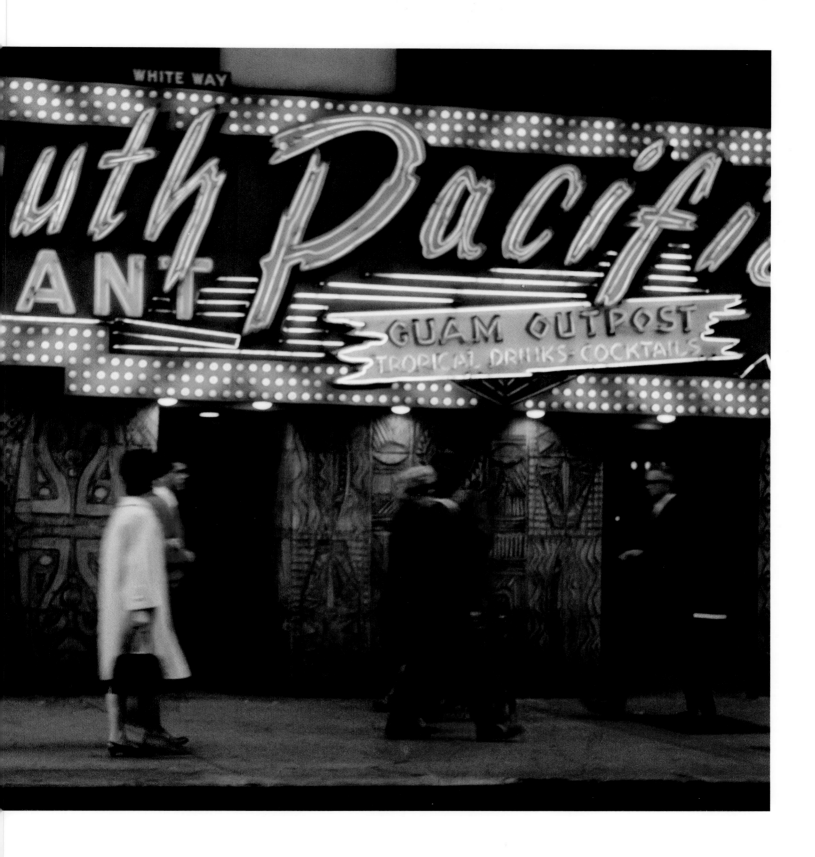

South Pacific restaurant, Chicago, 1966

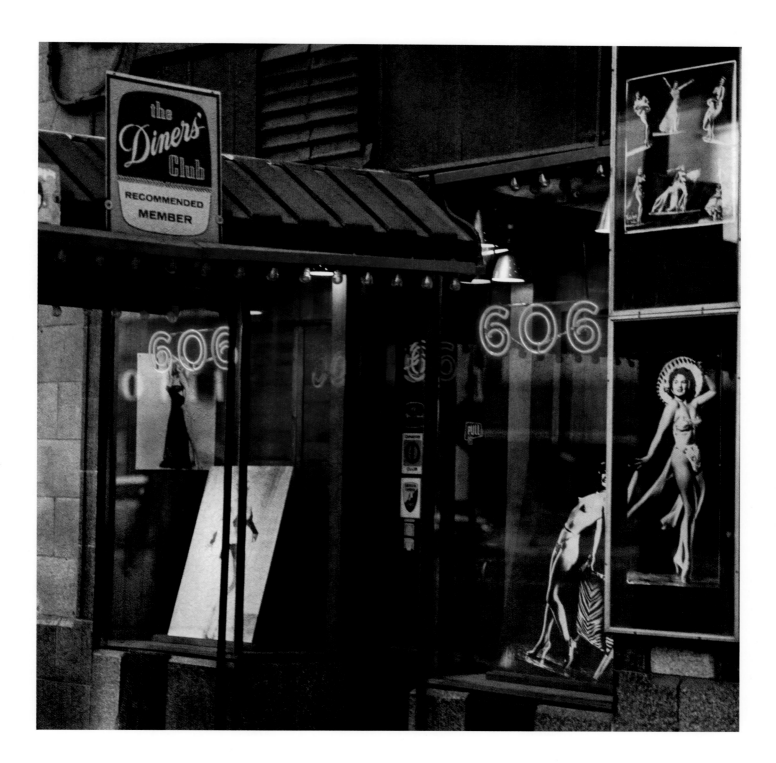

Club 606, Chicago, 1966

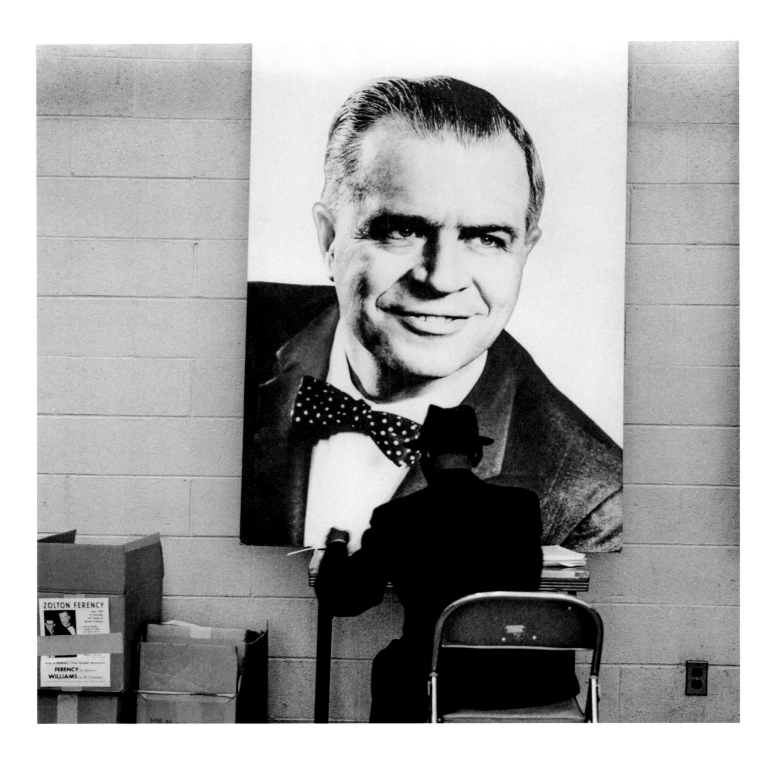

Vote, Detroit, 1966

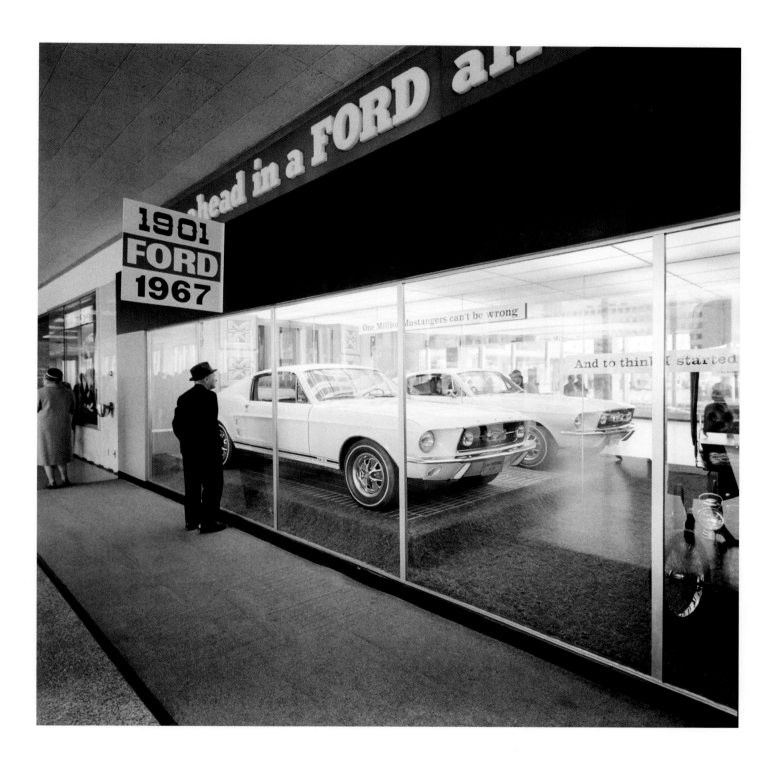

Ford Car Expo, Detroit, 1966

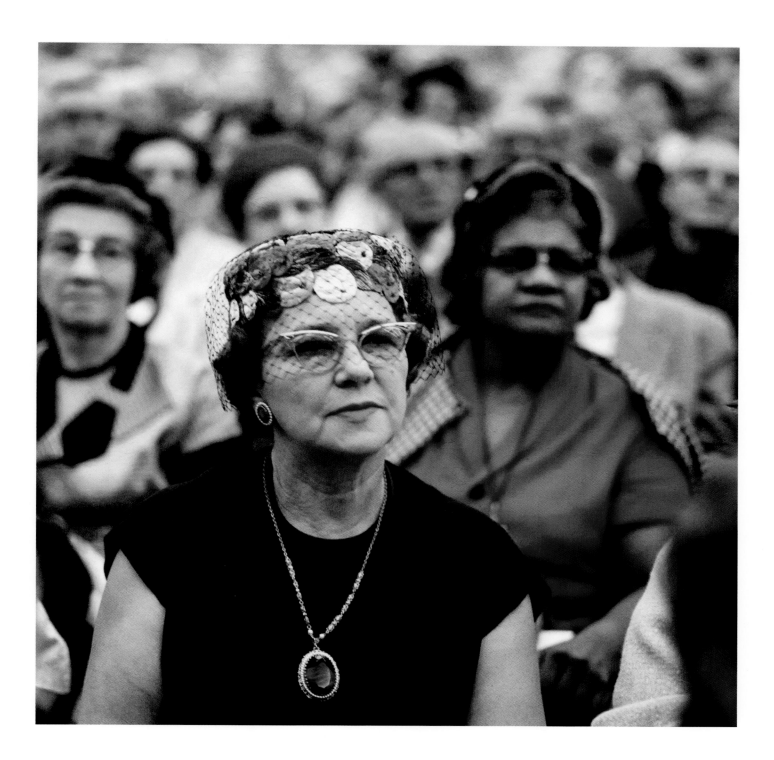

Retired trade union worker, Detroit, 1966

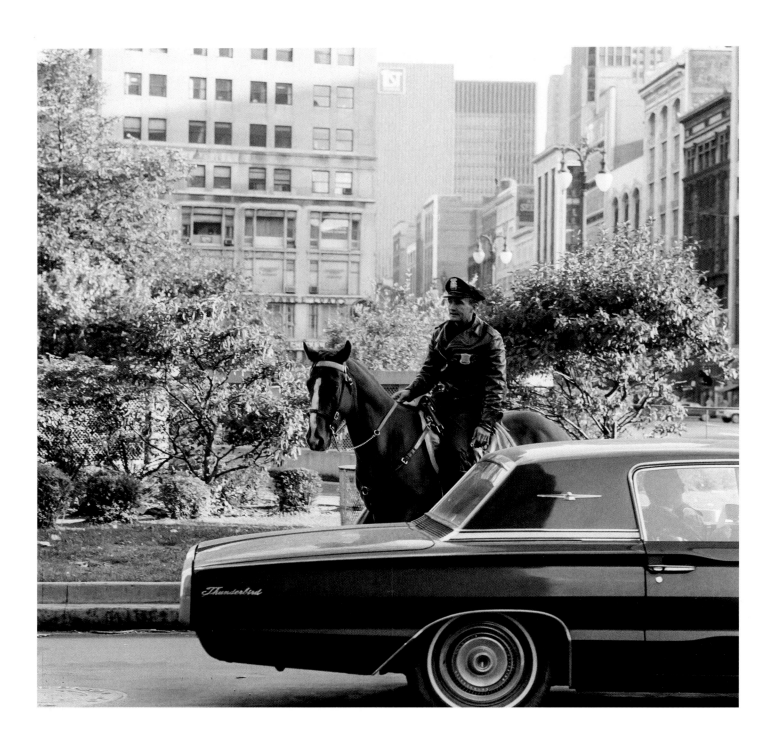

Police, Detroit, 1966

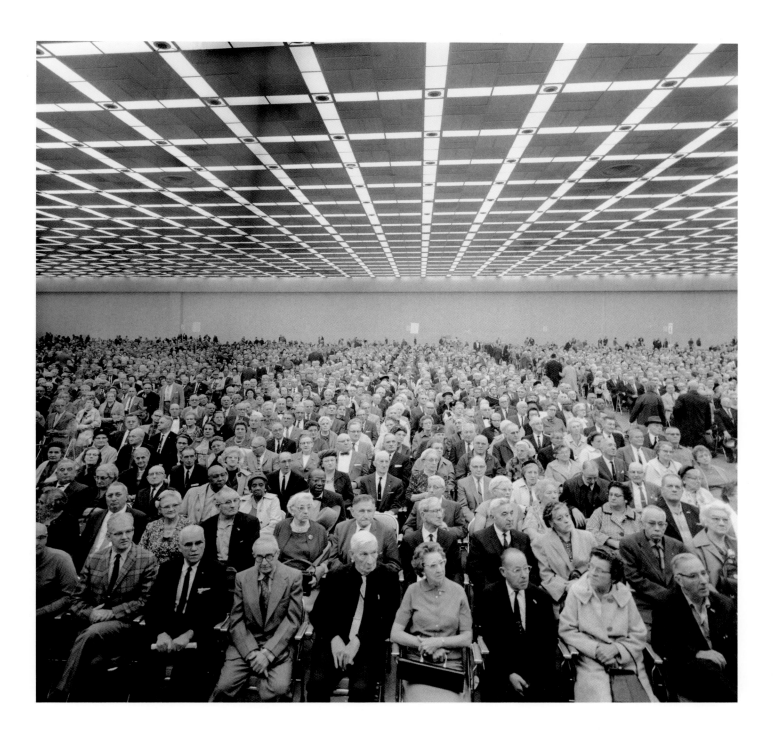

Retired trade union workers, Detroit, 1966

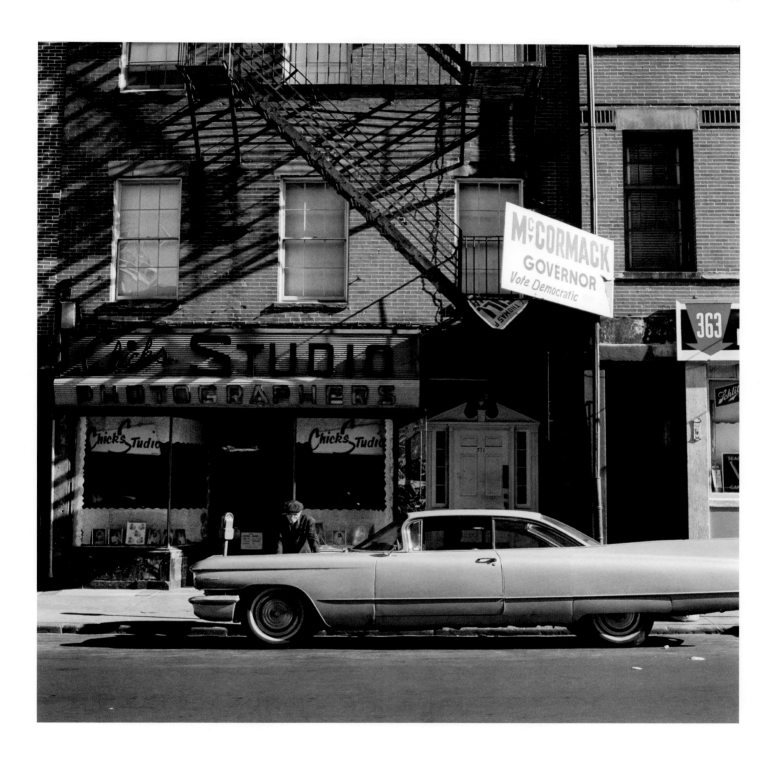

Photographer's studio, Boston, 1966

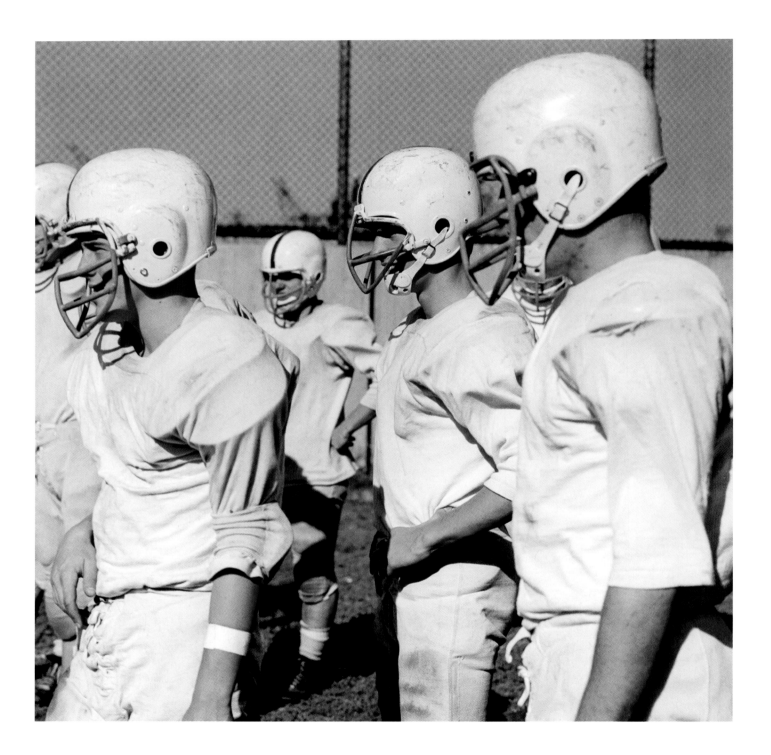

Football players, Boston, 1966

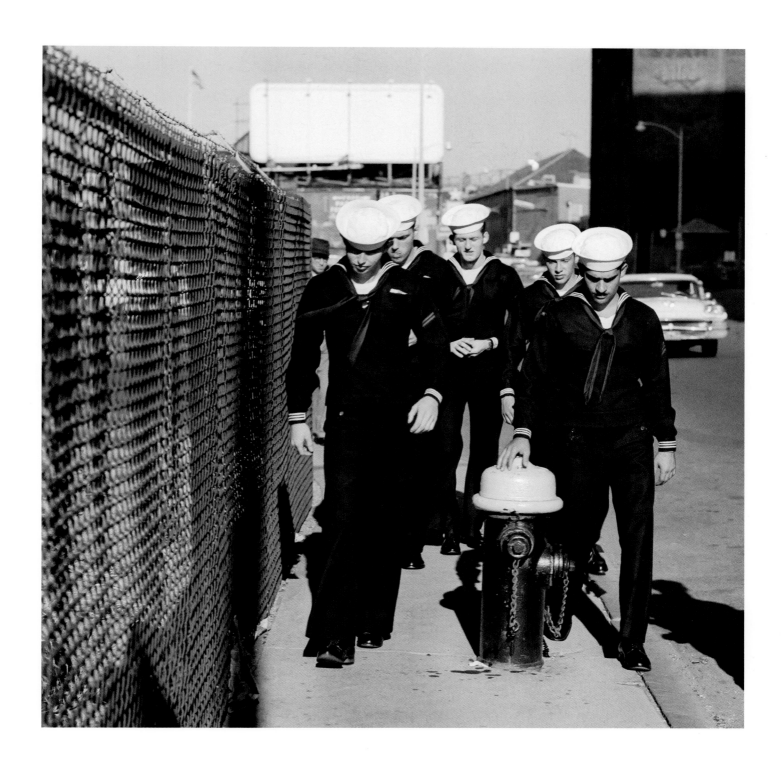

Marines, Boston, 1966

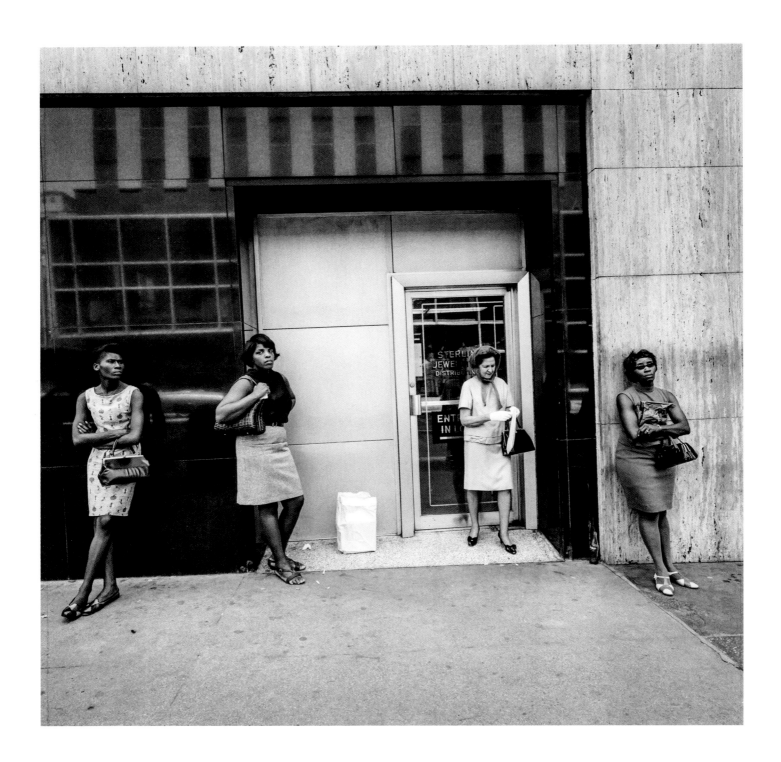

Jewellery store, Dallas, 1967

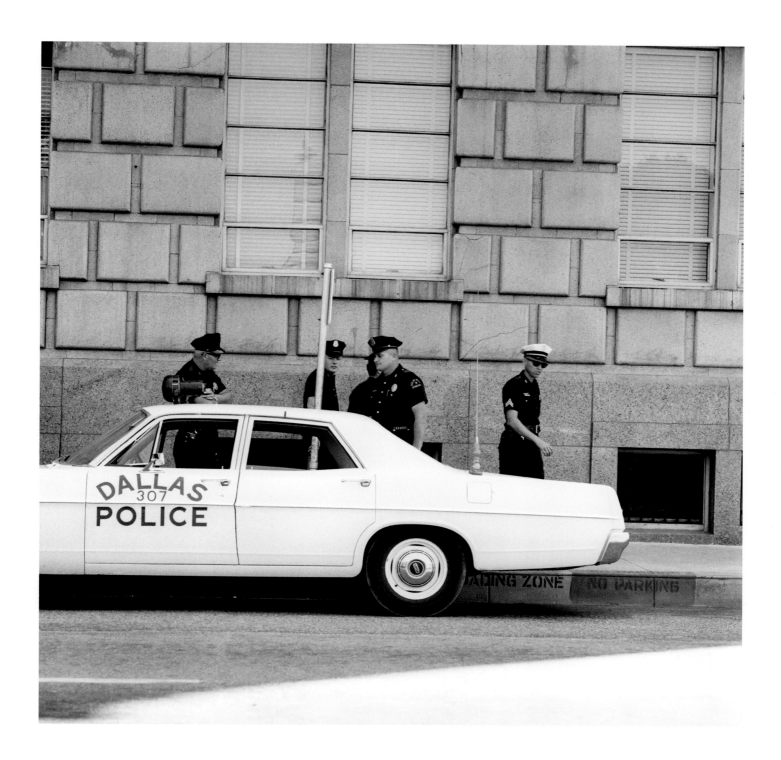

Police car, Dallas, 1967

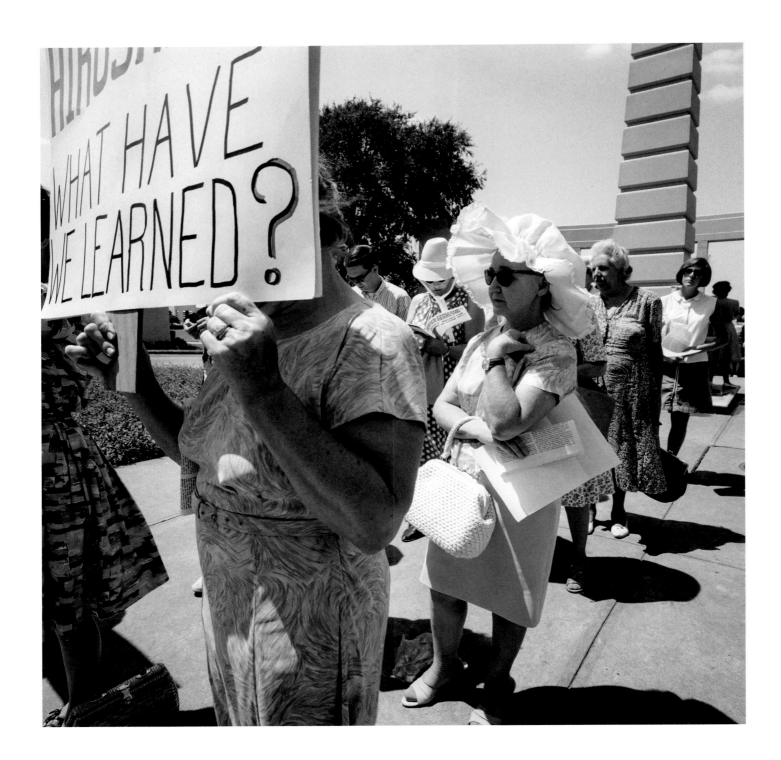

Anti-war demonstration, Dallas, 1967

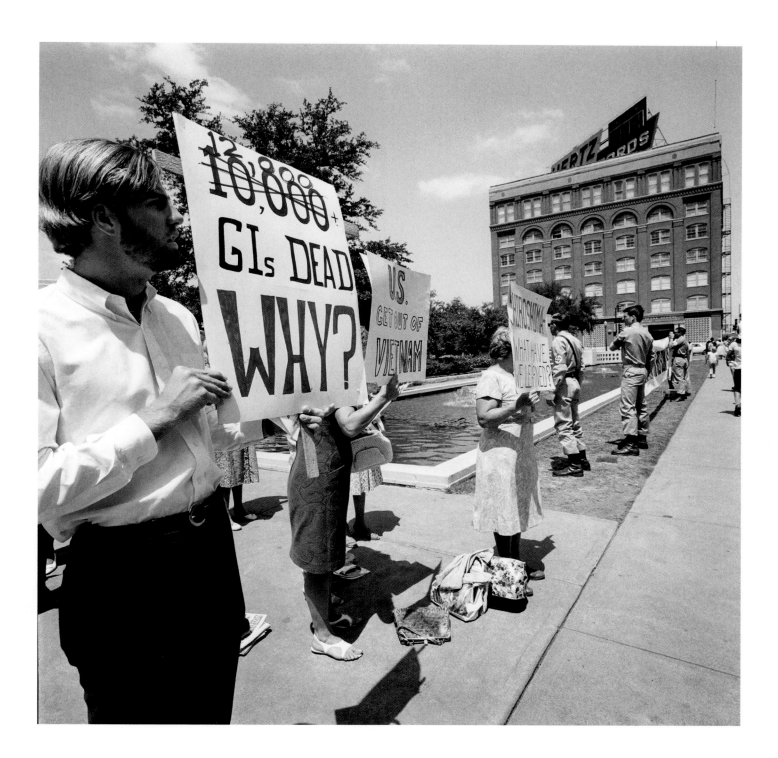

Anti-war demonstration, Dallas, 1967

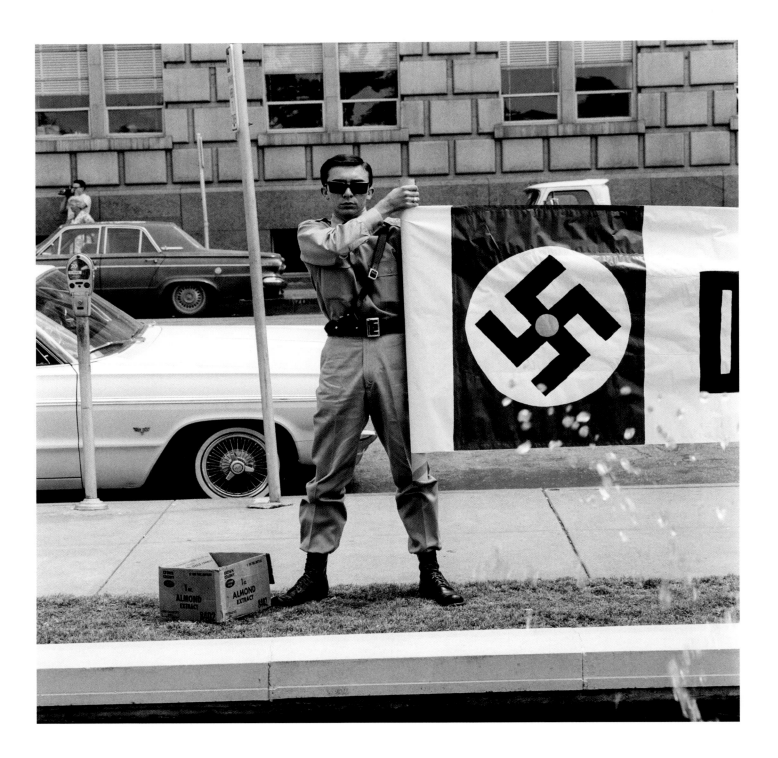

Neo-Nazi demonstrator, Dallas, 1967

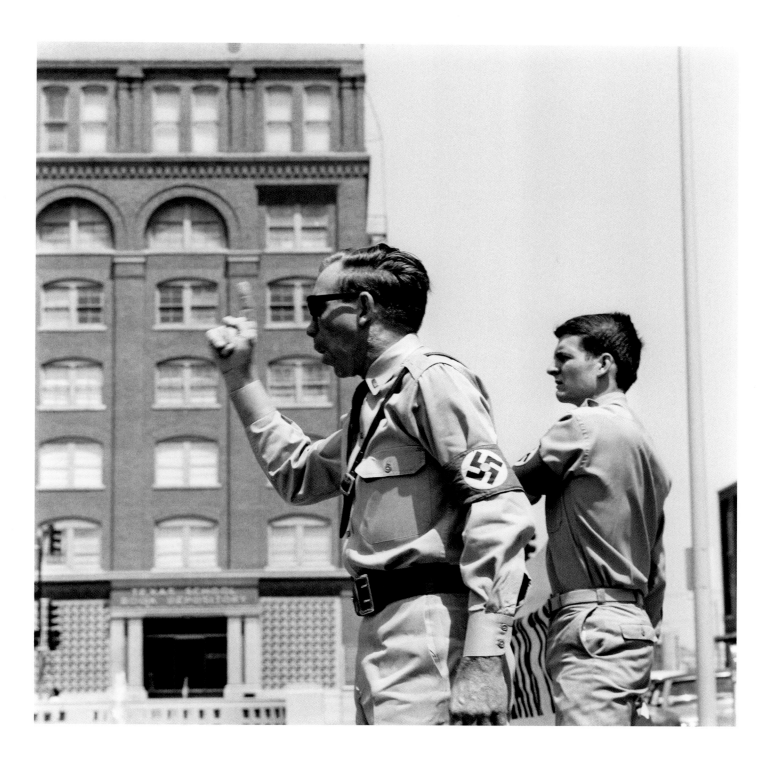

Neo-Nazi speaker, Dallas, 1967

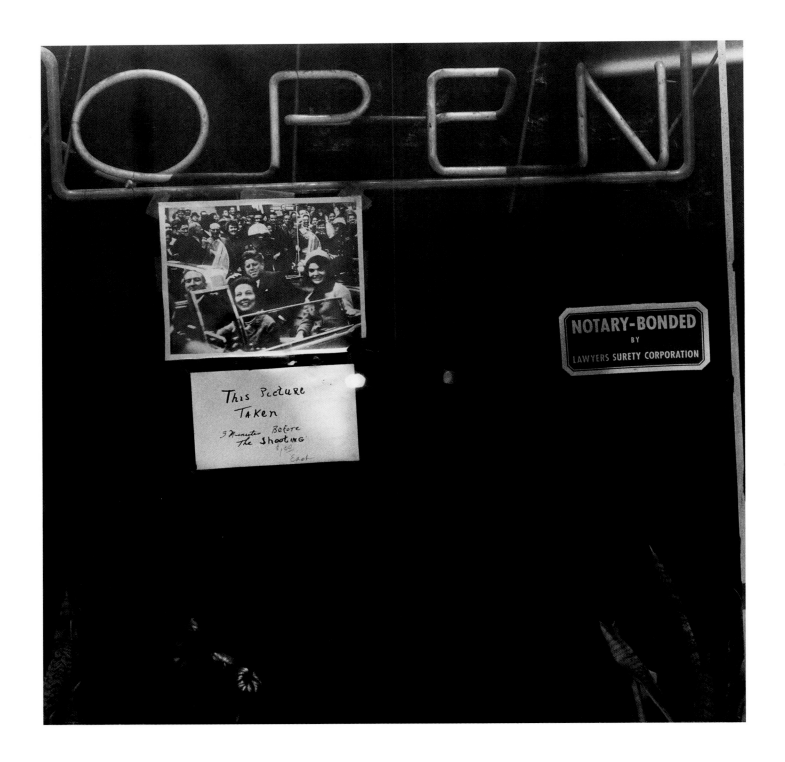

$1 photo, Dallas, 1967

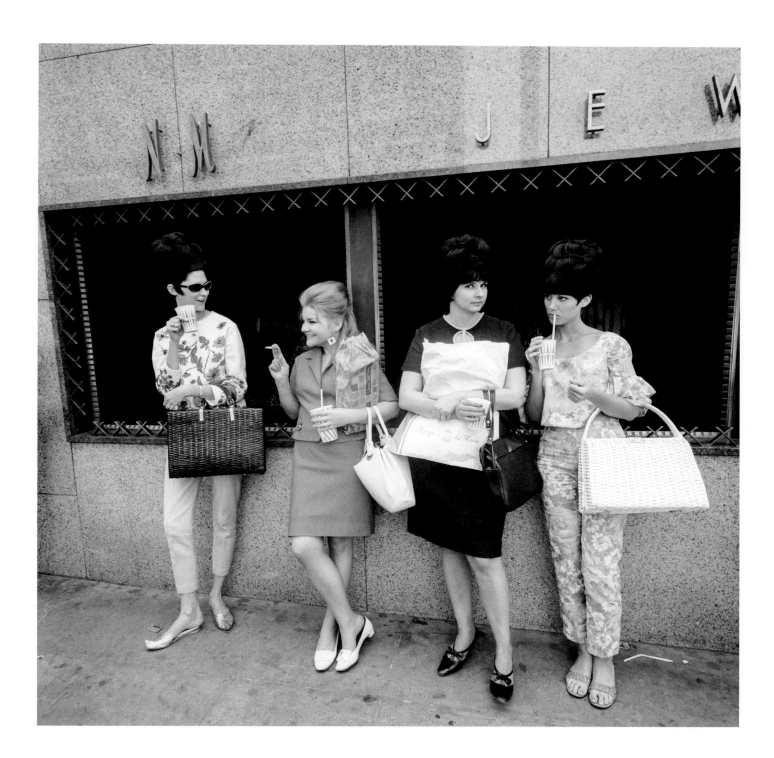

Neiman Marcus, Dallas, 1967

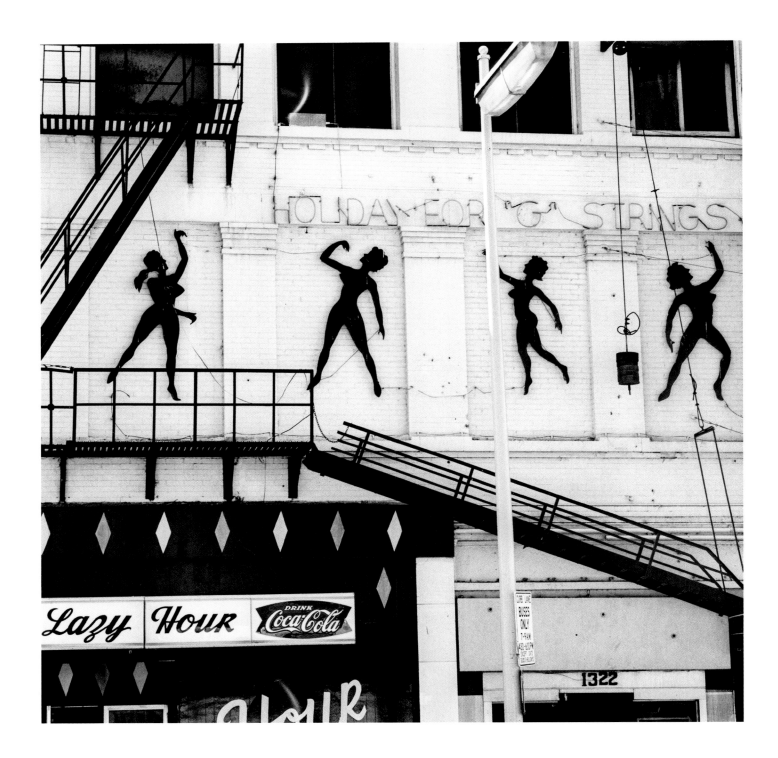

Lazy hour, El-Paso, 1967

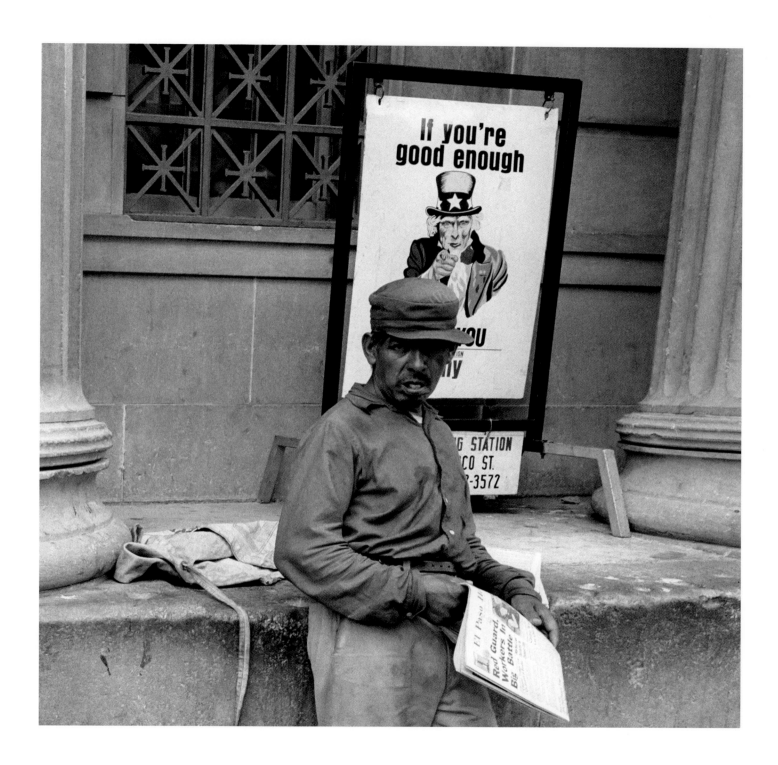

Newspaper seller, El-Paso, 1967

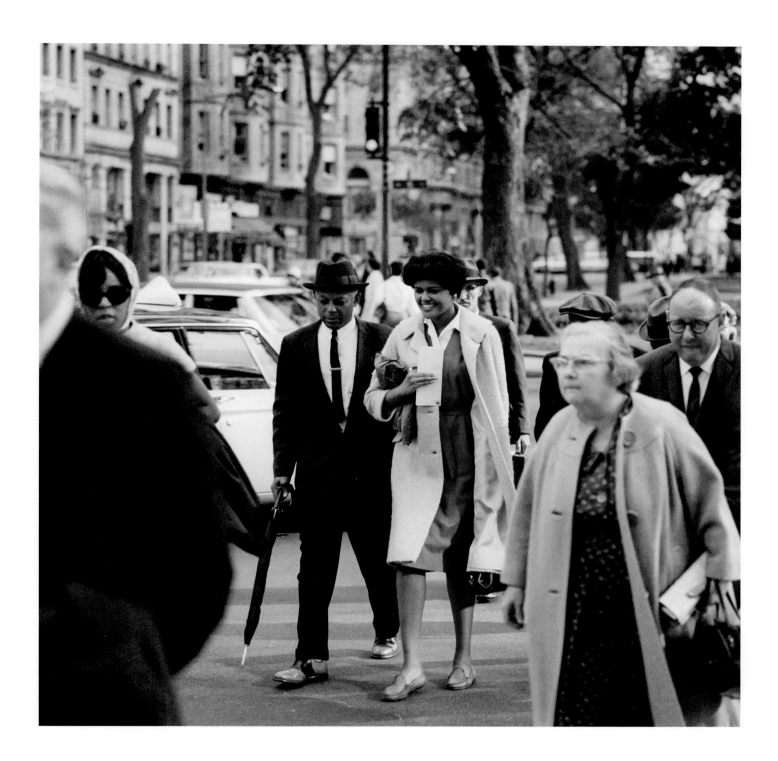

After work stroll, Washington D.C., 1966

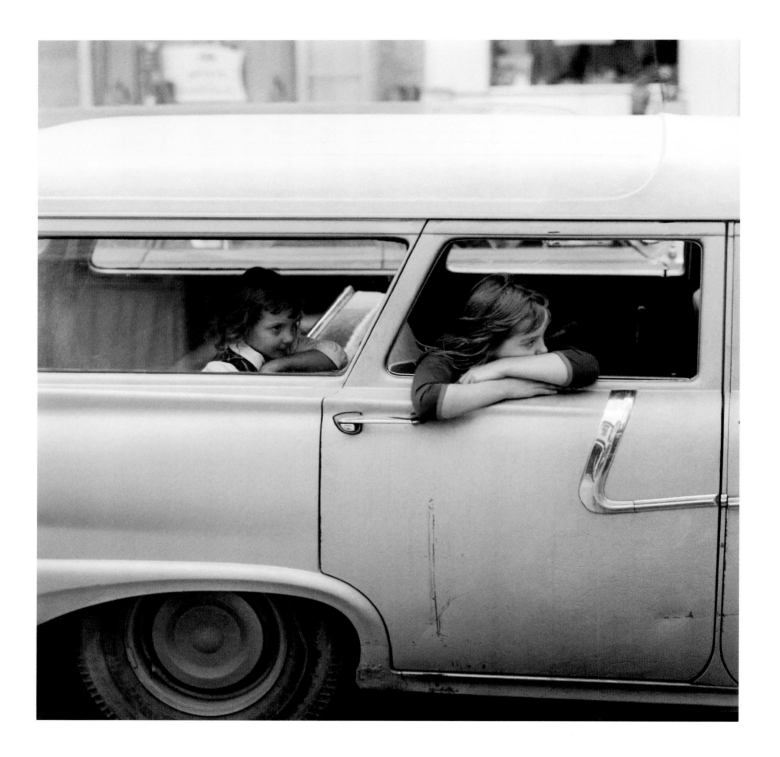

Two girls in a car, Washington D.C., 1966

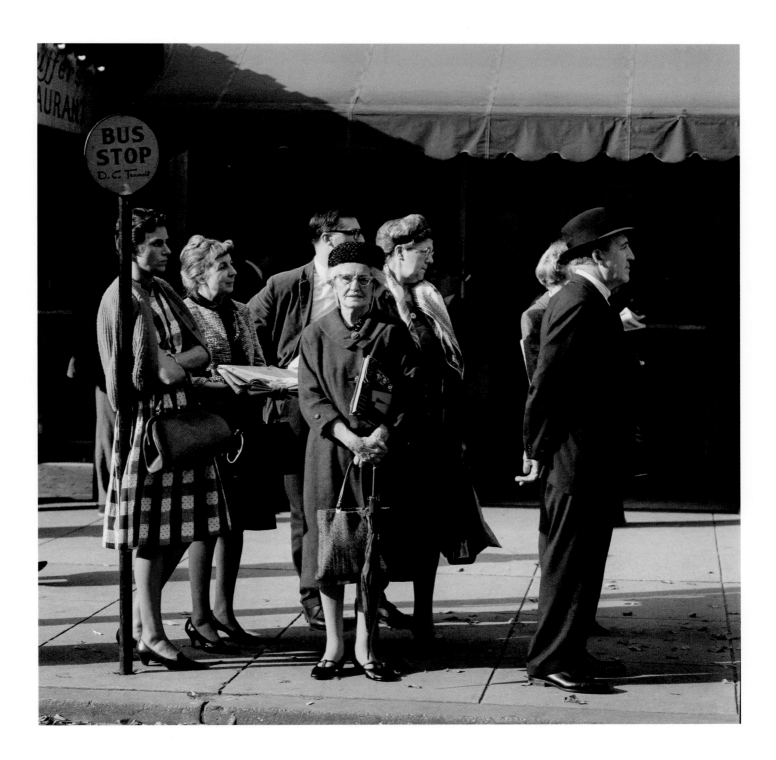

Bus stop, Washington D.C., 1966

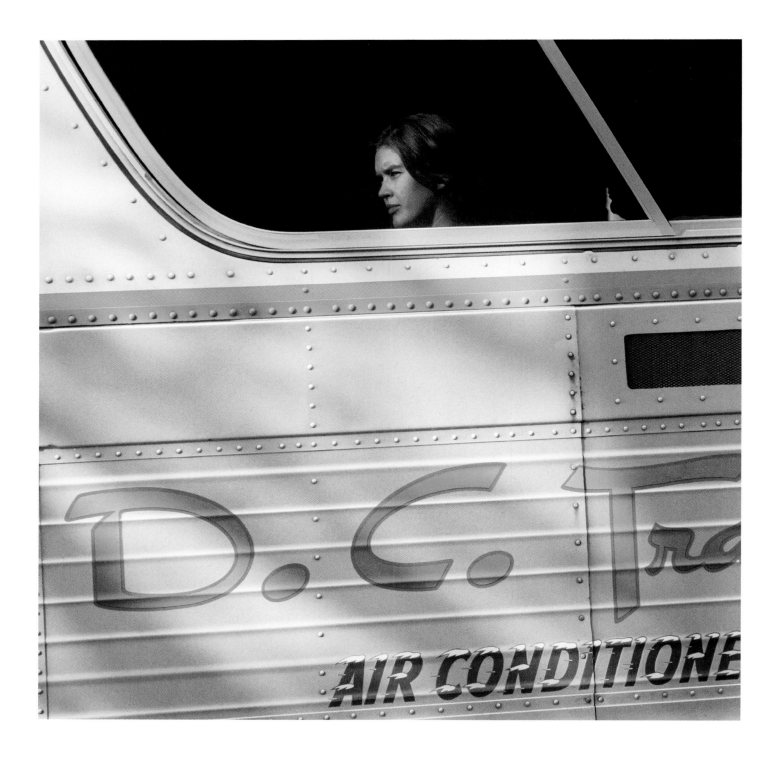

Bus station, Washington D.C., 1966

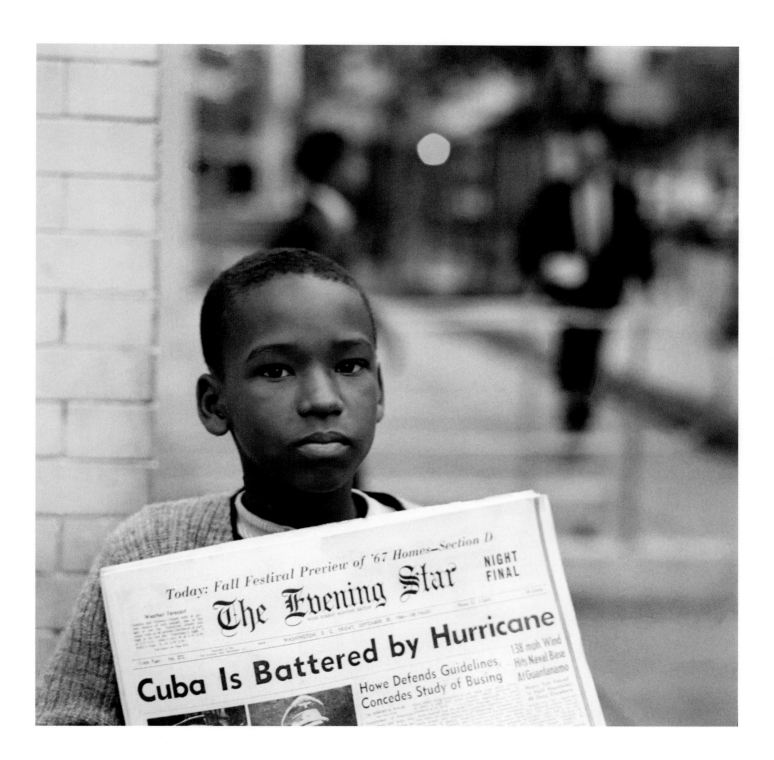

Evening Star seller, Washington D.C., 1966

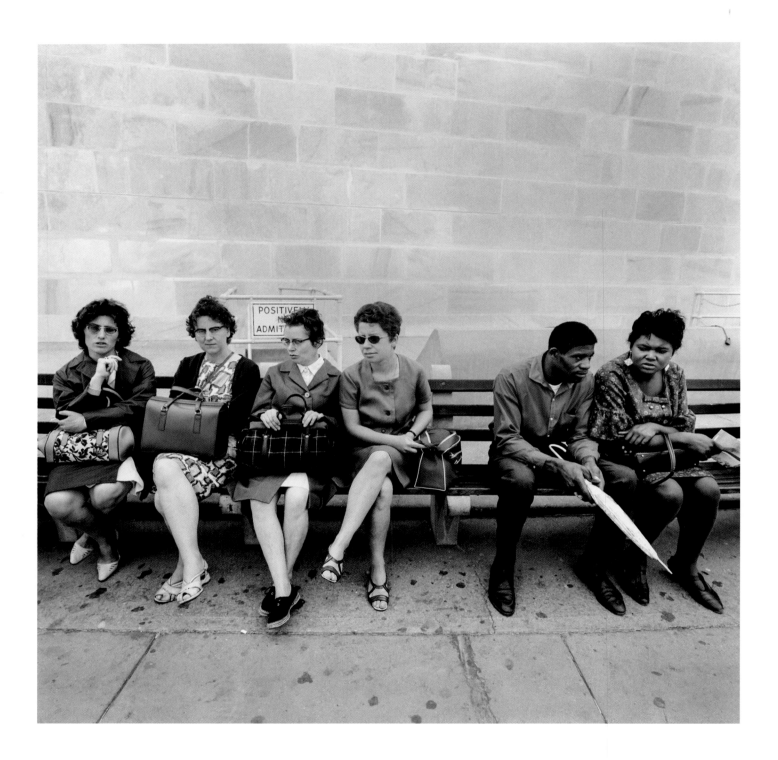

Lincoln Memorial, Washington D.C., 1967

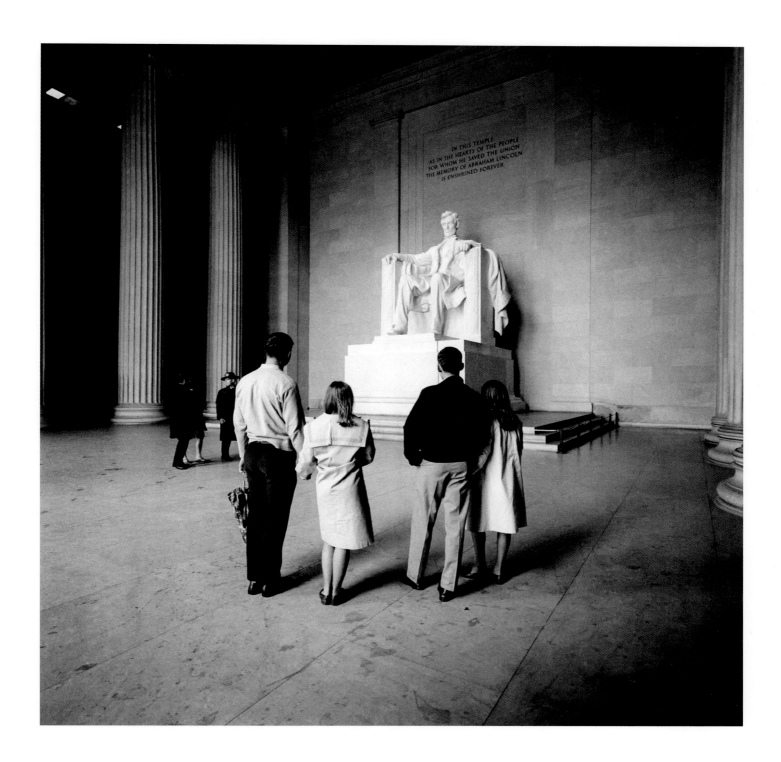

Lincoln Memorial, Washington D.C., 1967

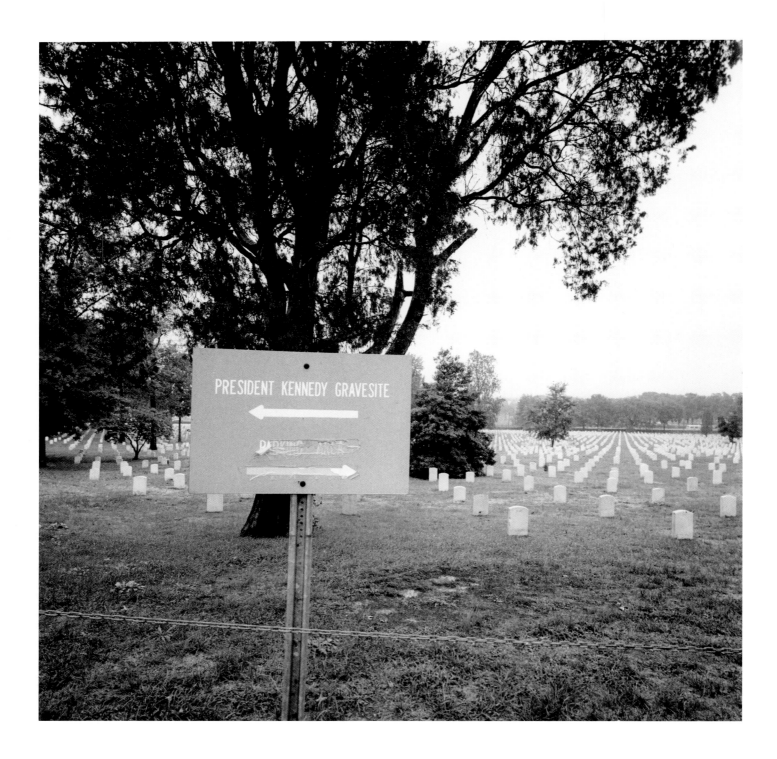

President Kennedy Gravesite, Washington D.C., 1966

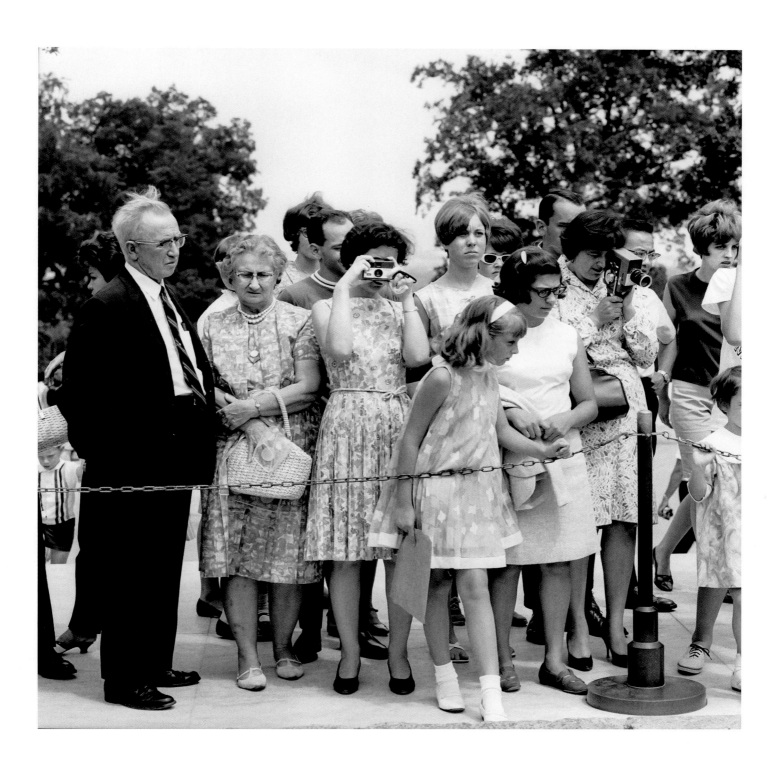

Tourists at the Eternal Flame, Washington D.C., 1966

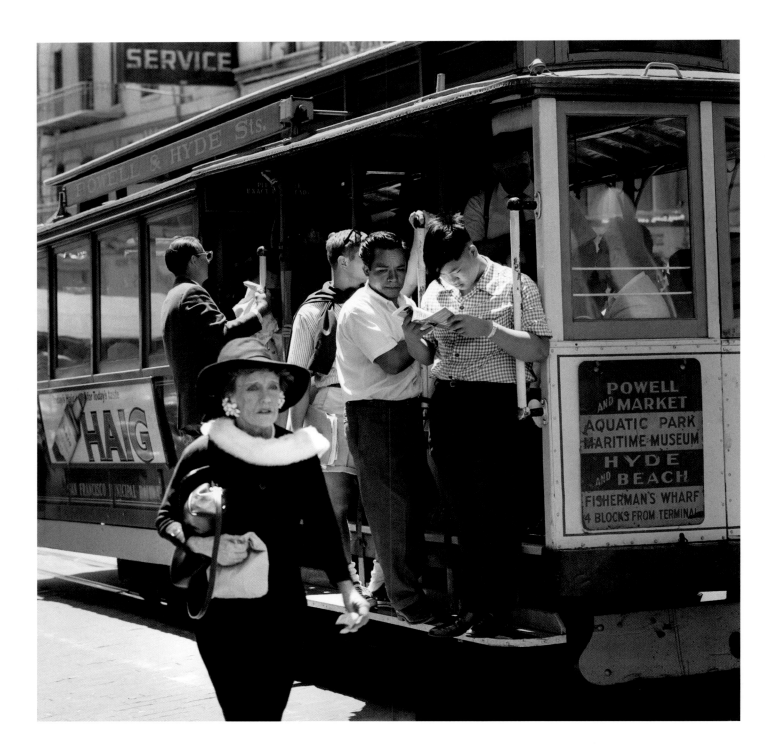

Well-dressed lady, San Francisco, 1967

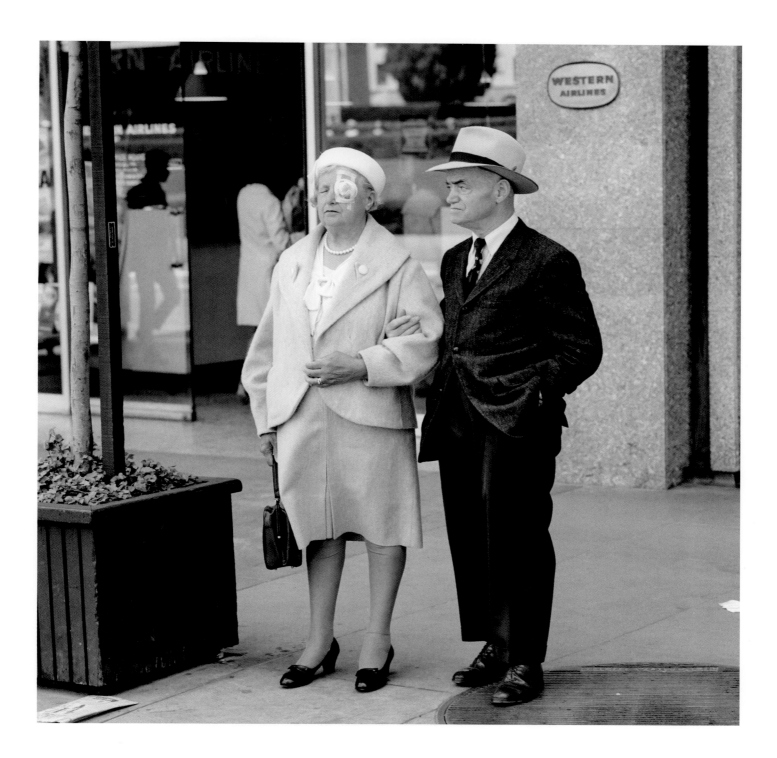

Couple, San Francisco, 1967

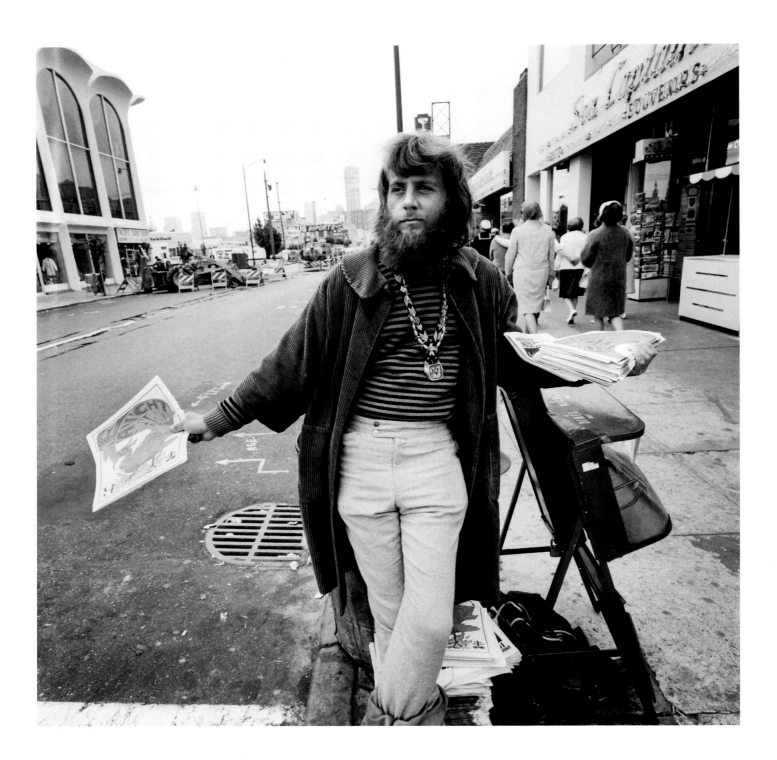

Hippie, San Francisco, 1967

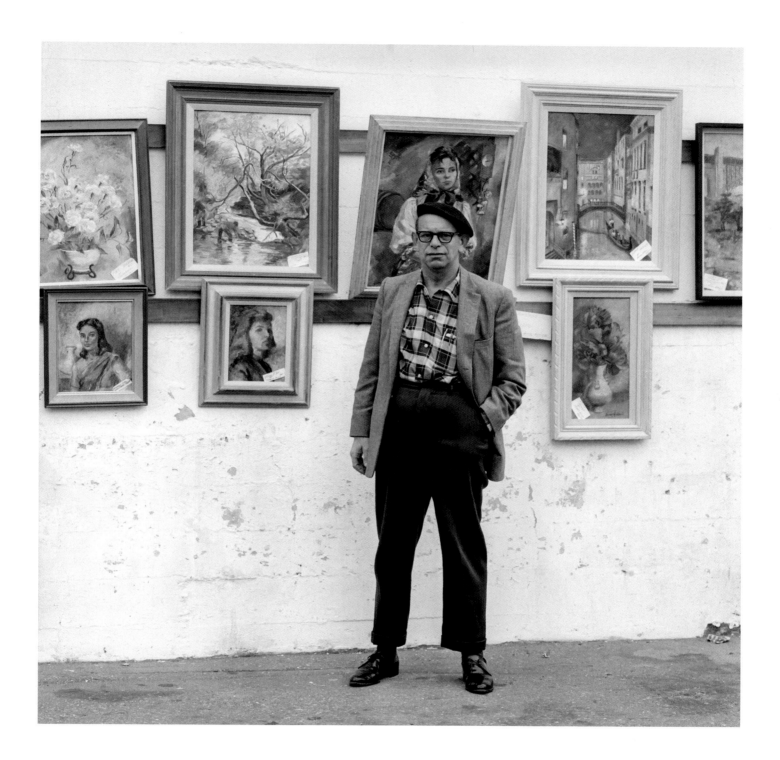

Painter, San Francisco, 1967

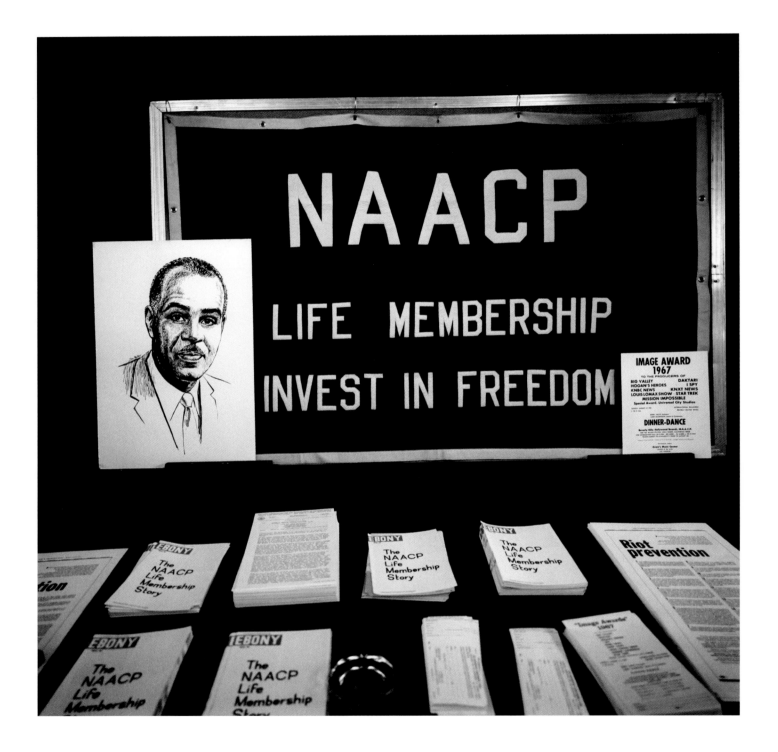

NAACP, Los Angeles, 1967

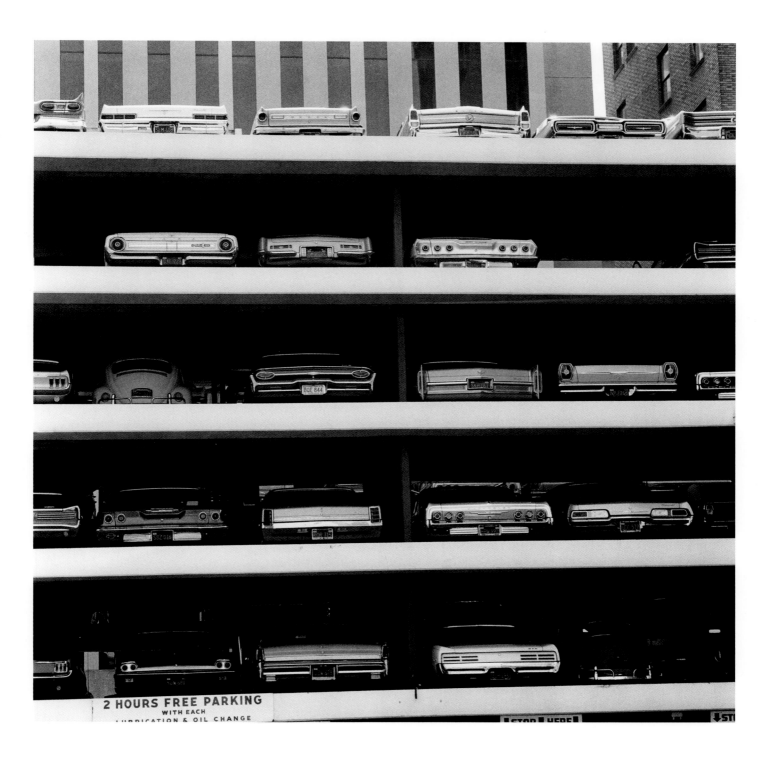

Parking lot, Los Angeles, 1967

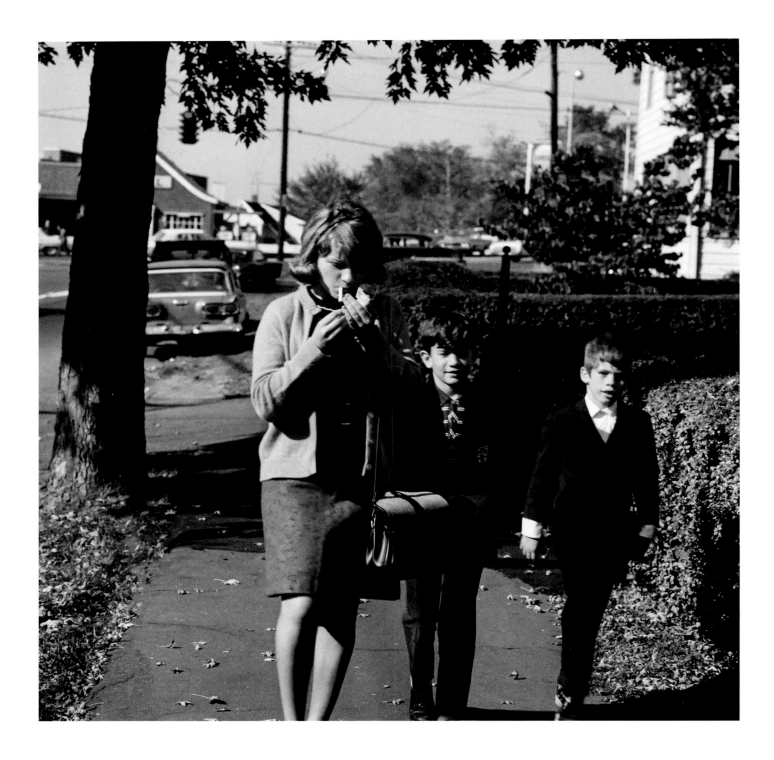

After school, Buffalo, 1966

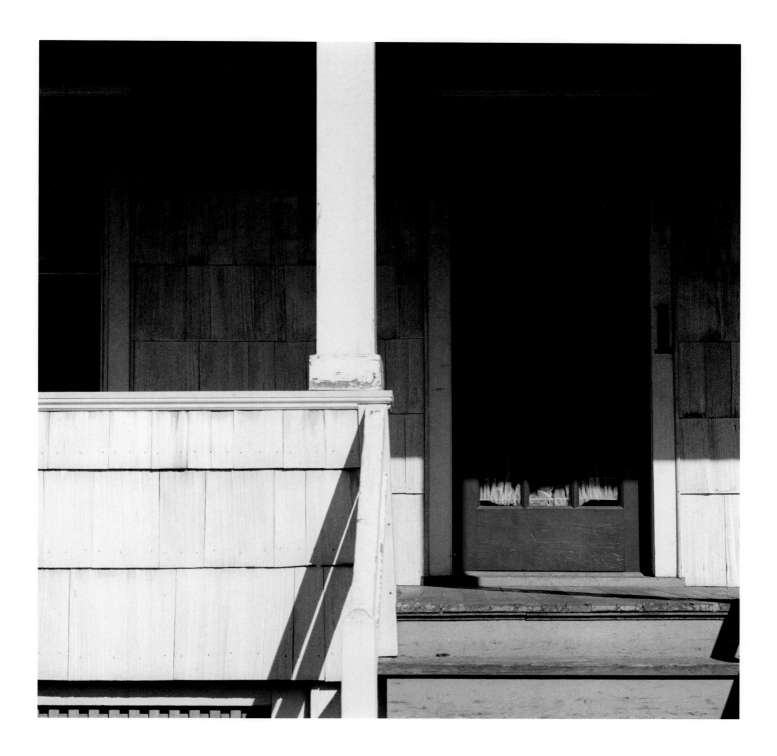

Red door, Stanford, 1966

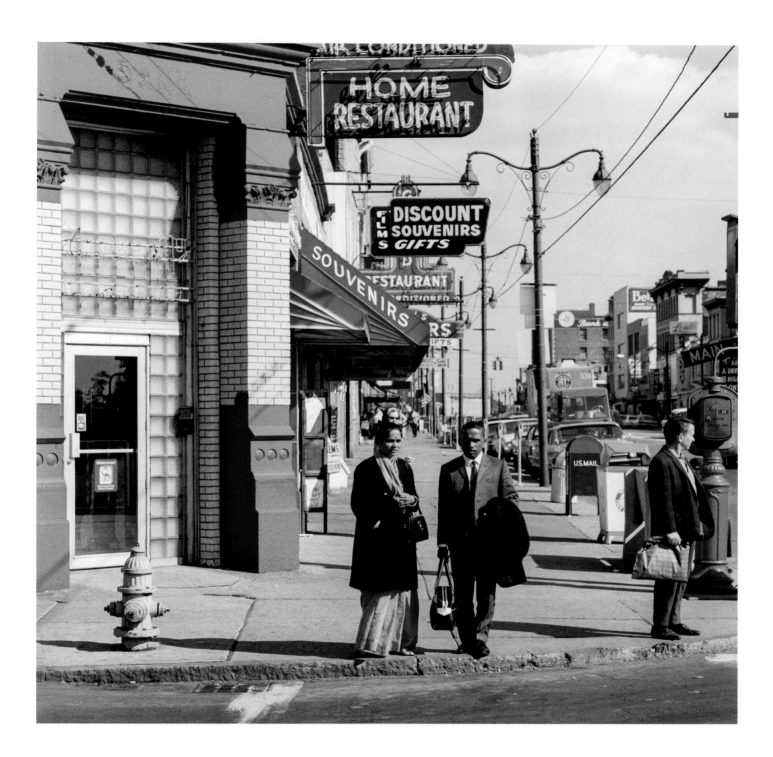

Immigrants, Buffalo, 1966

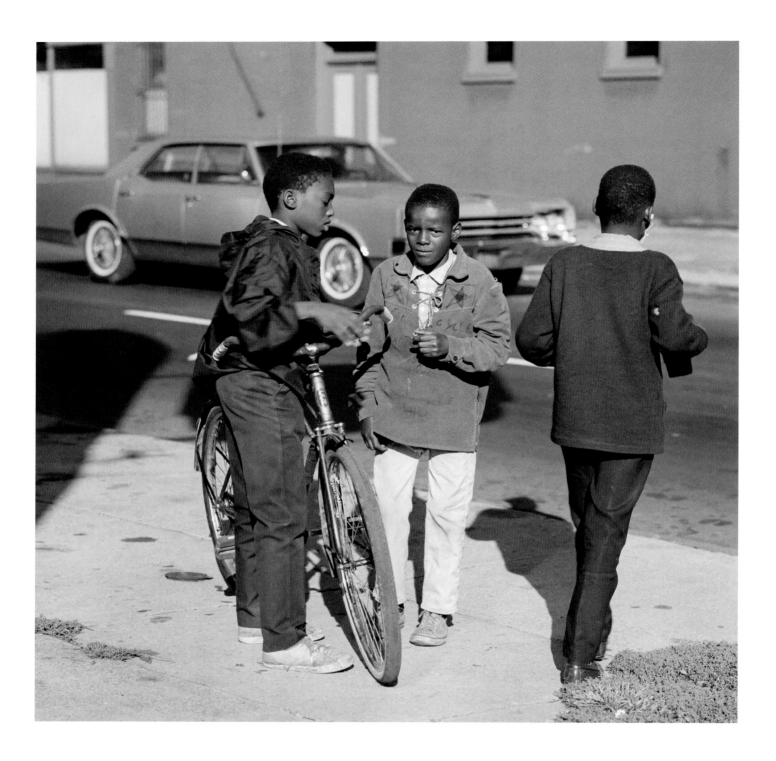

Kids, Buffalo, 1966

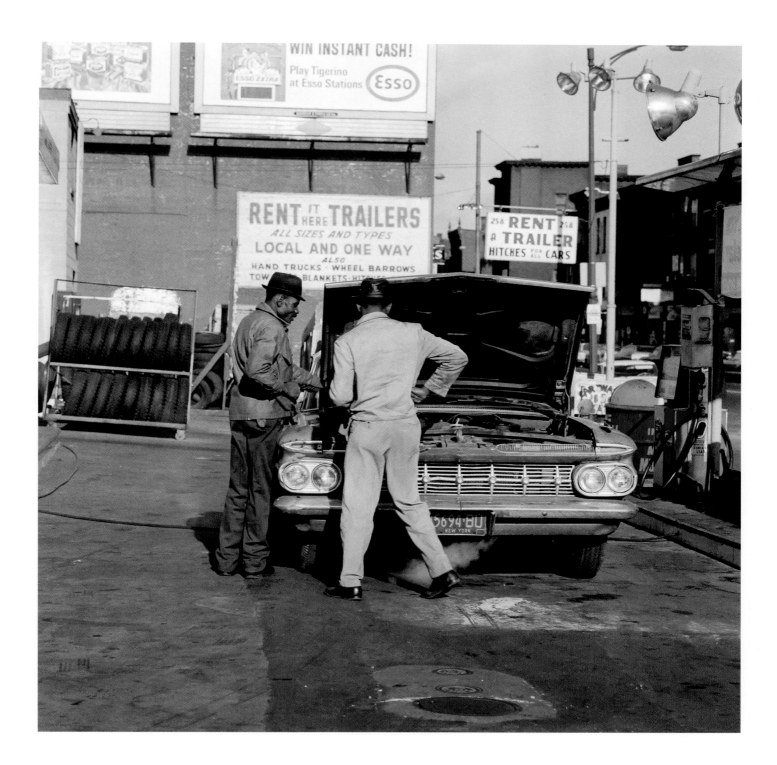

Auto shop, Buffalo, 1966

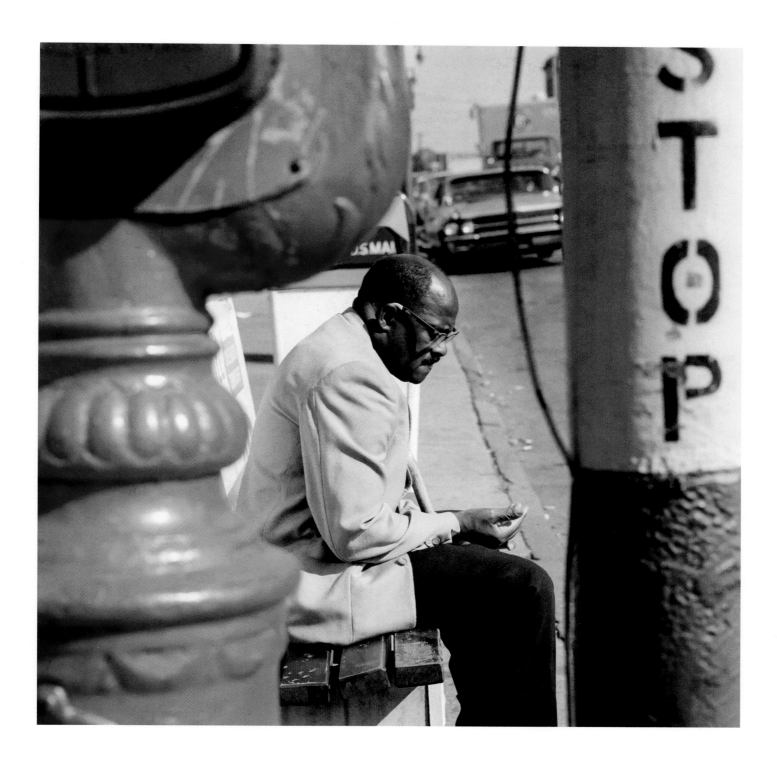

Bus stop, Buffalo, 1966

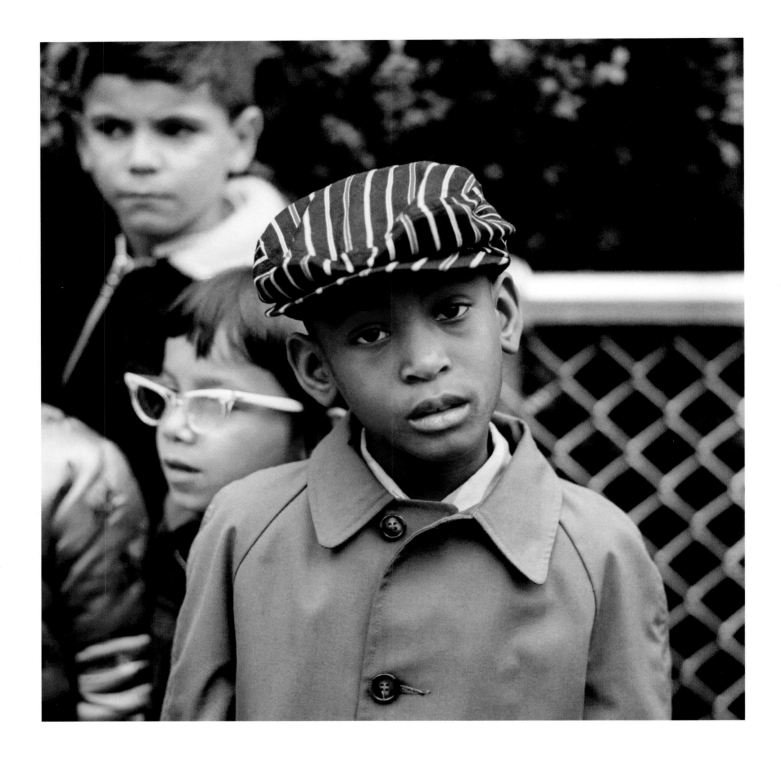

Schoolboy, New York, 1966

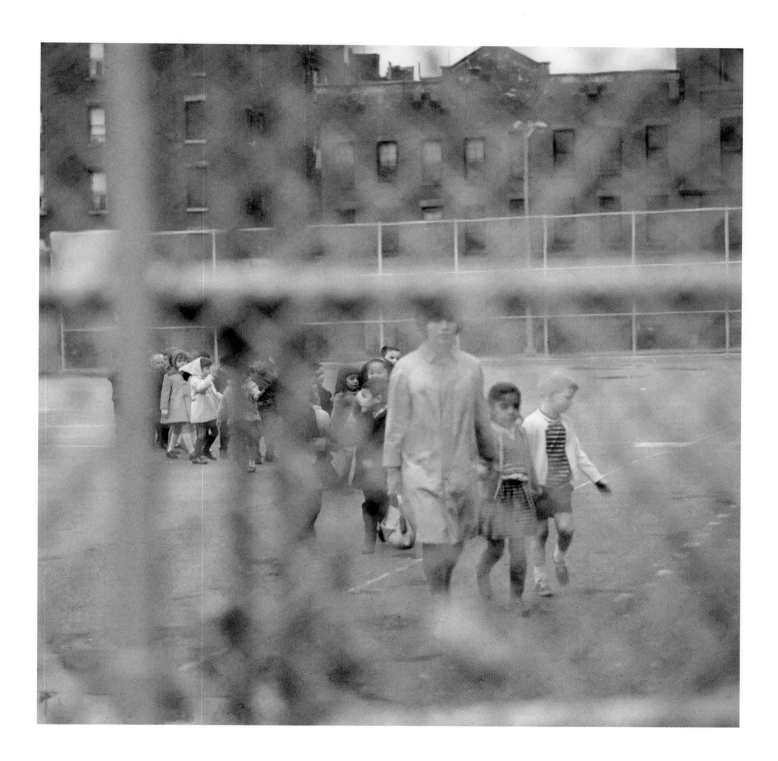

Primary school, New York, 1966

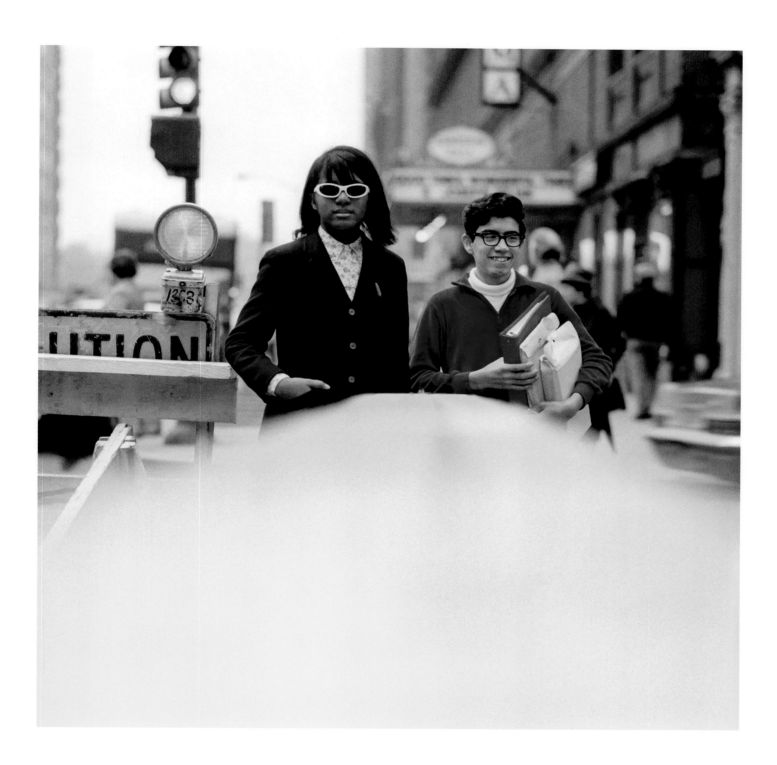

Fashion students, New York, 1966

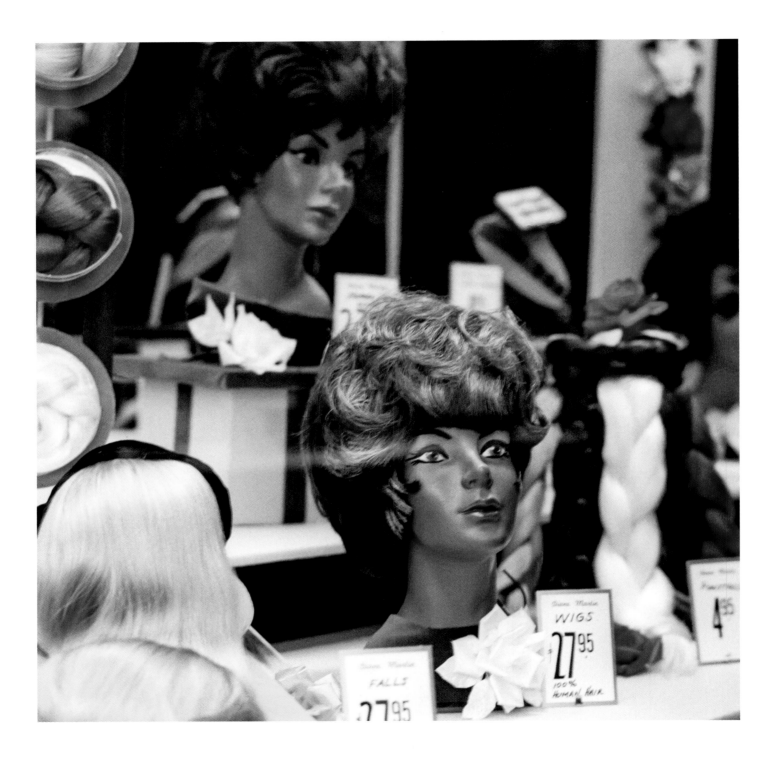

Wig store, New York, 1966

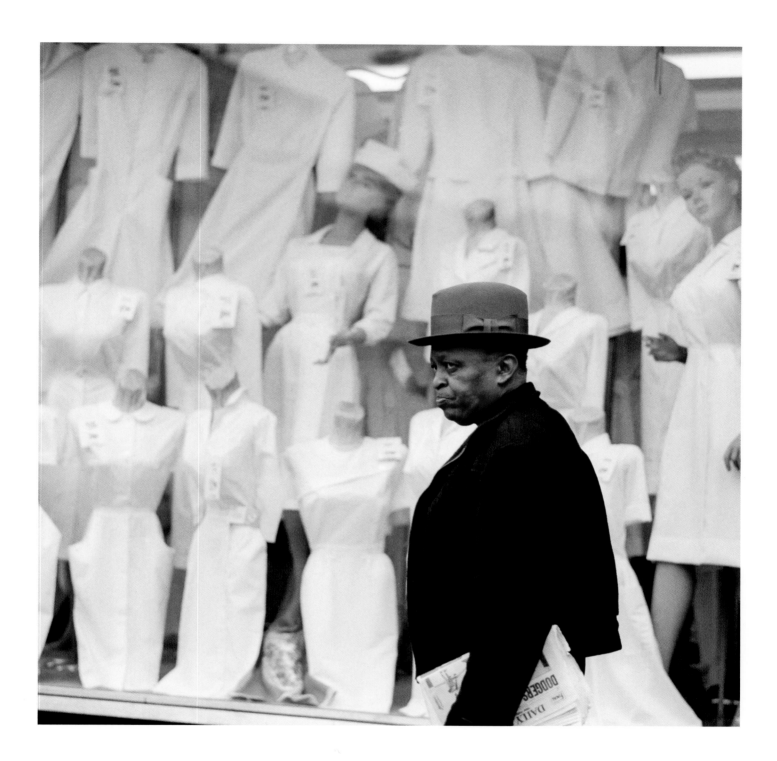

Nurses outfitters, New York, 1966

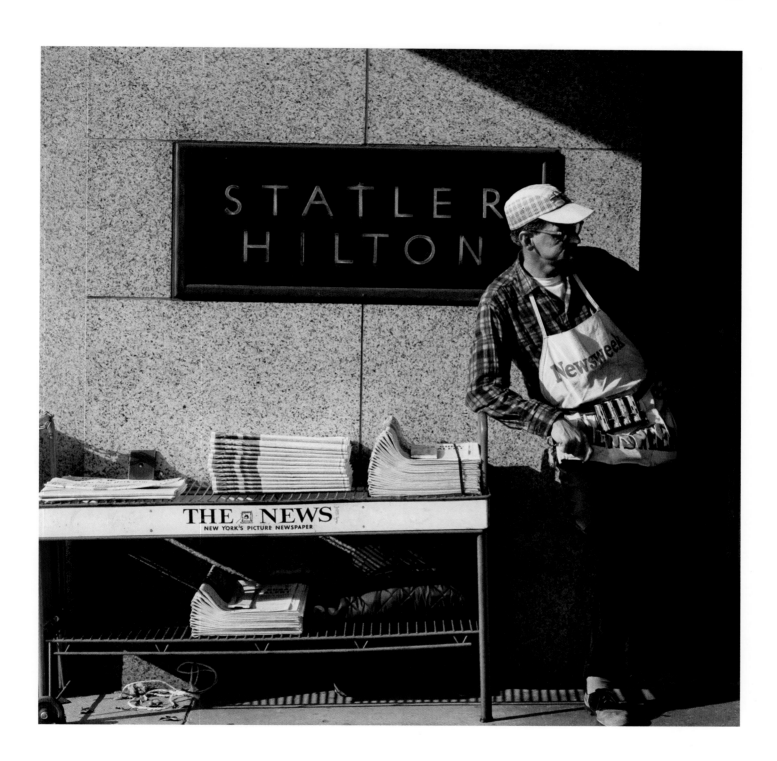

Newsstand, New York, 1966

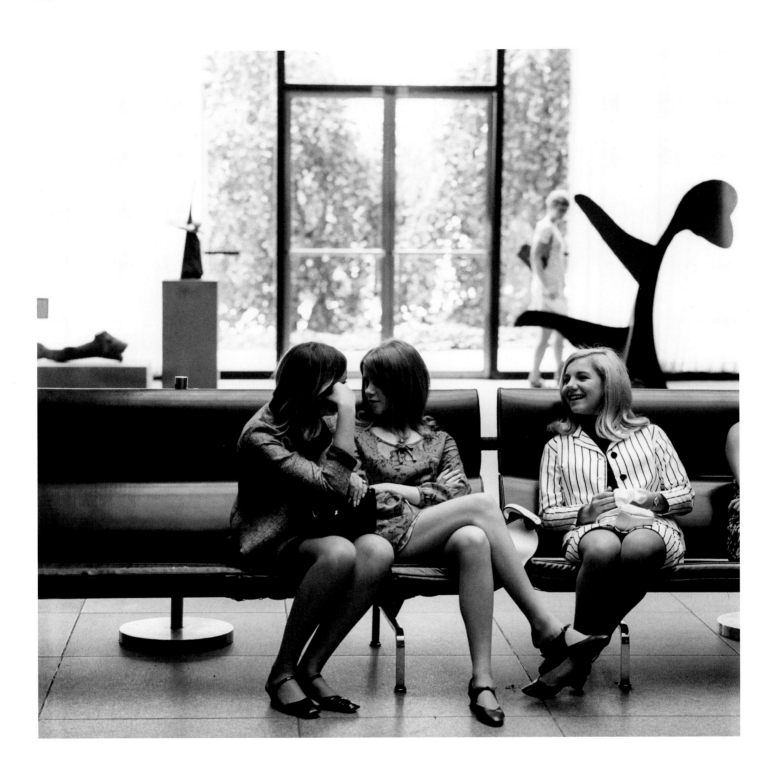

Museum of Modern Art, New York, 1967

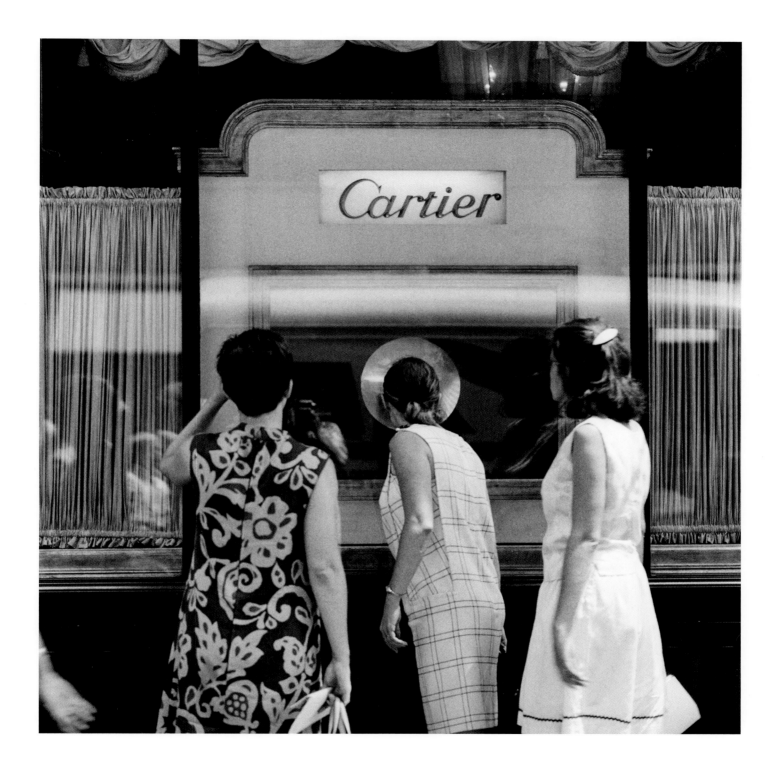

Cartier, New York, 1967

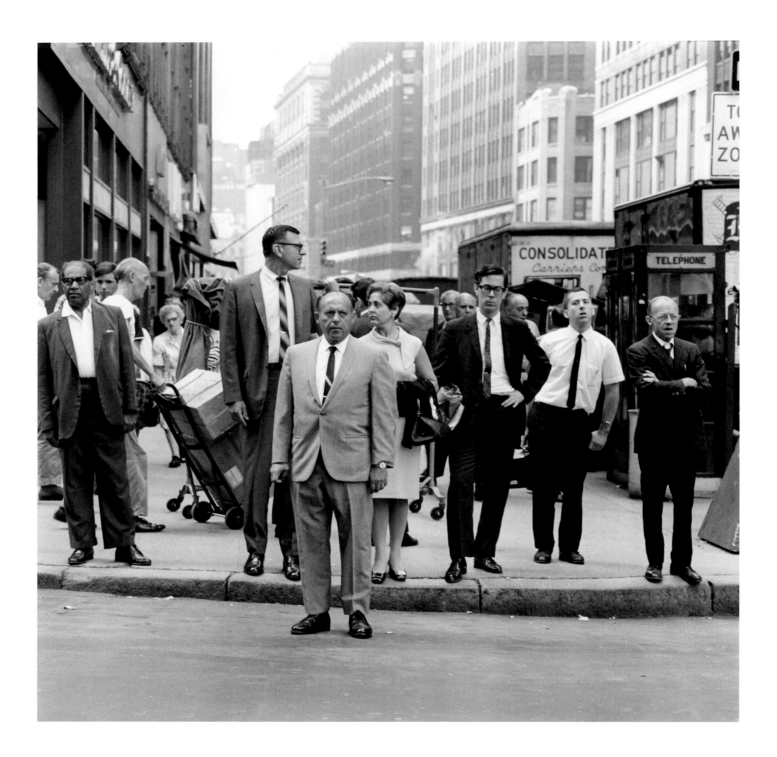

Traffic lights 1, New York, 1967

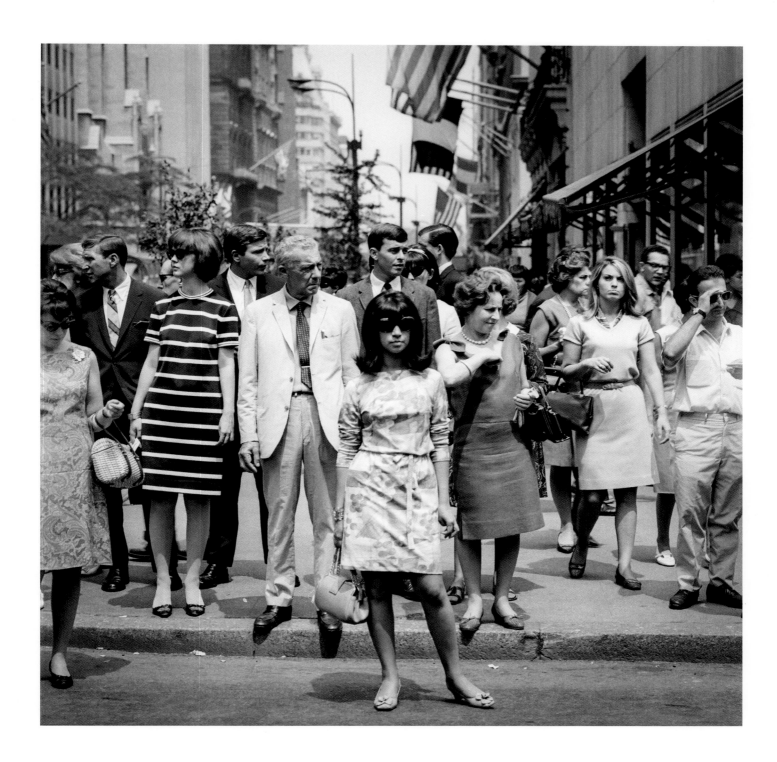

Traffic lights 2, New York, 1967

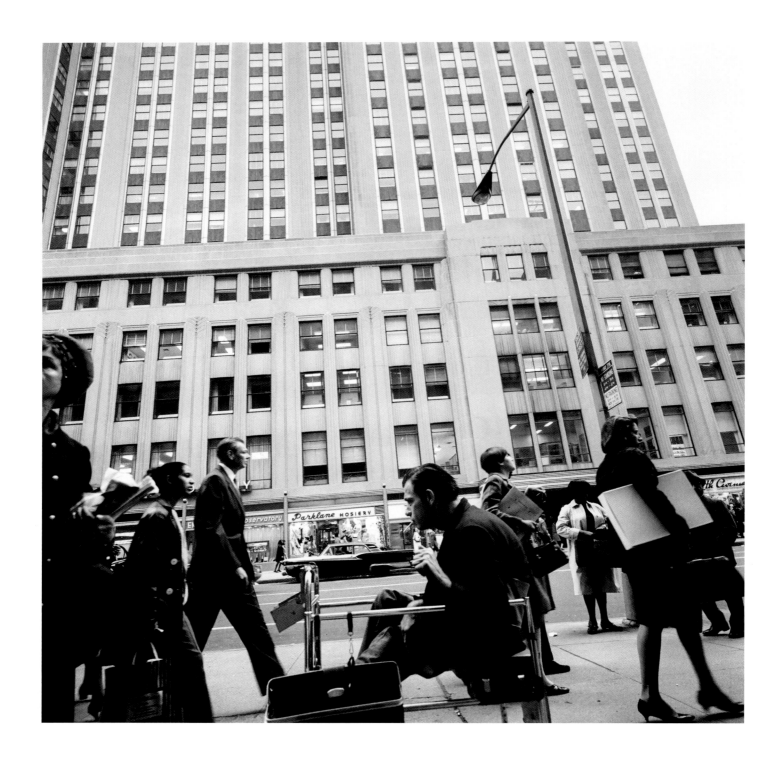

Beggar, New York, 1966

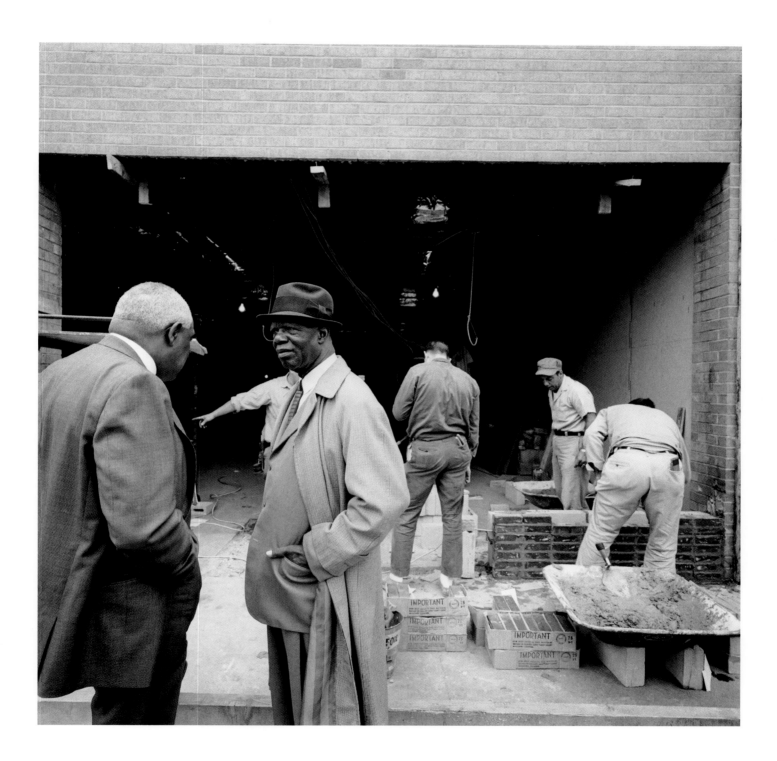

Entrepreneurs, New York, 1966

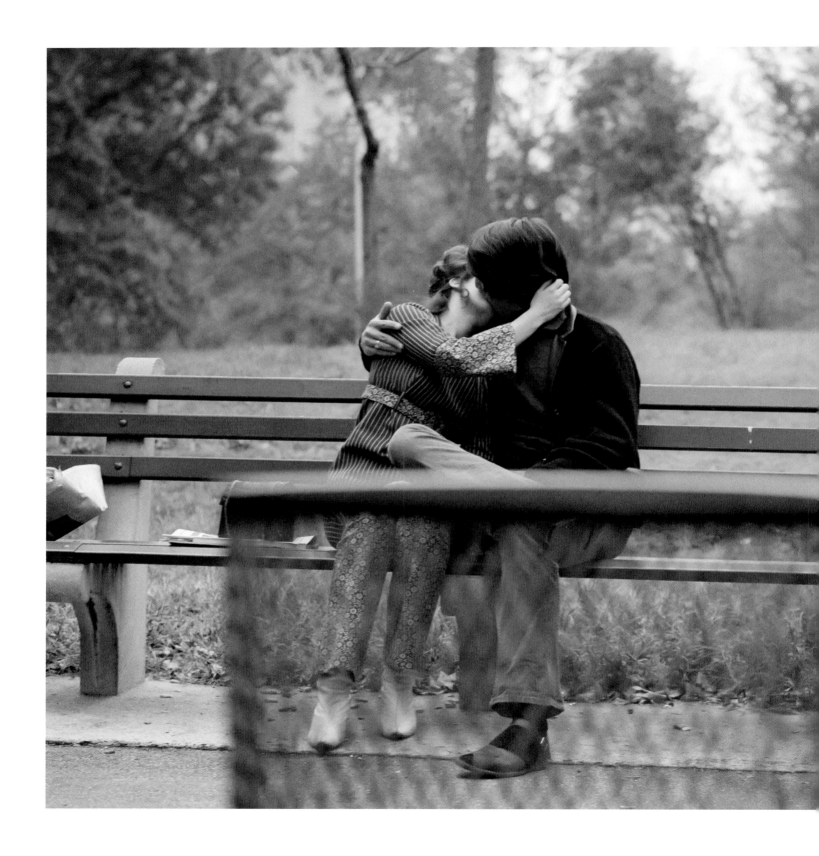

A kiss in the park, New York, 1966

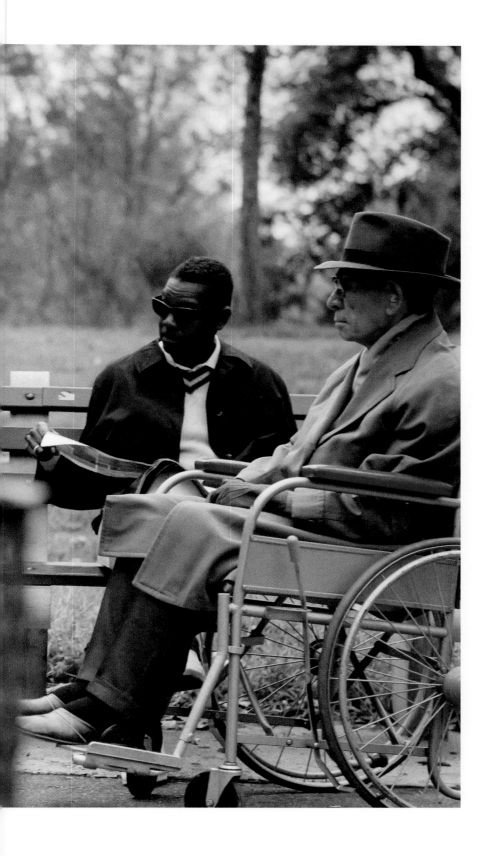

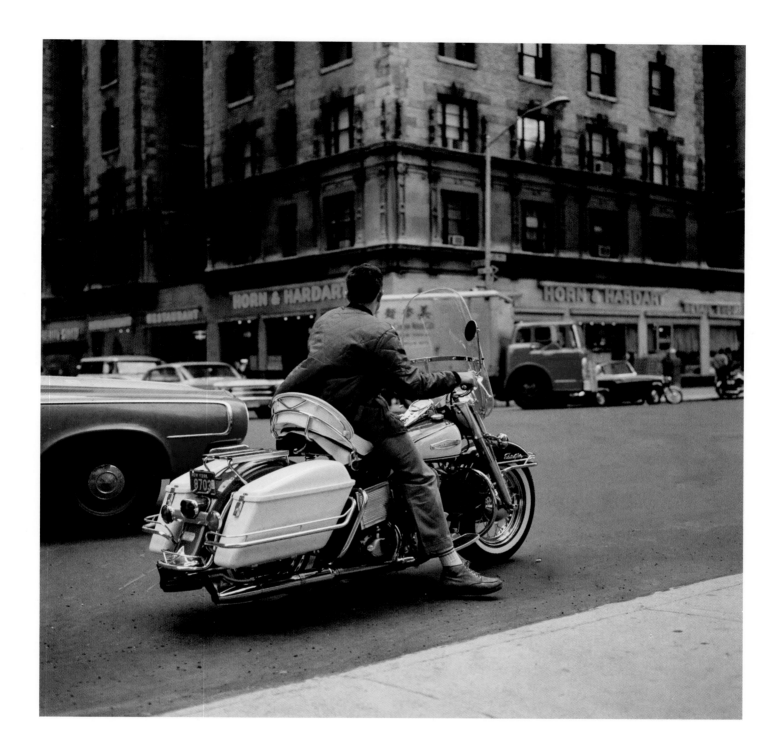

Motorbike rider, New York, 1966

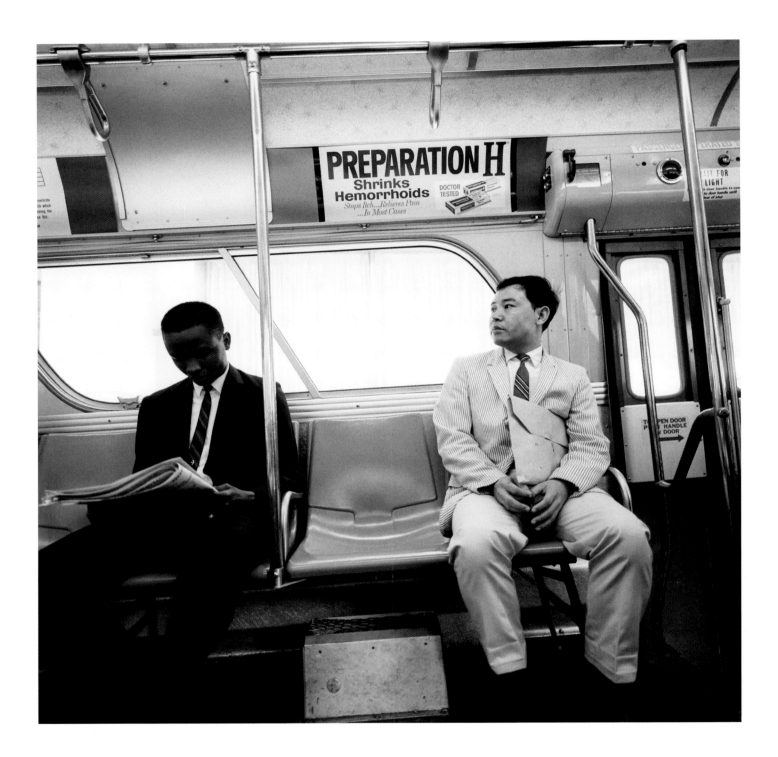

Bus riders, New York, 1967

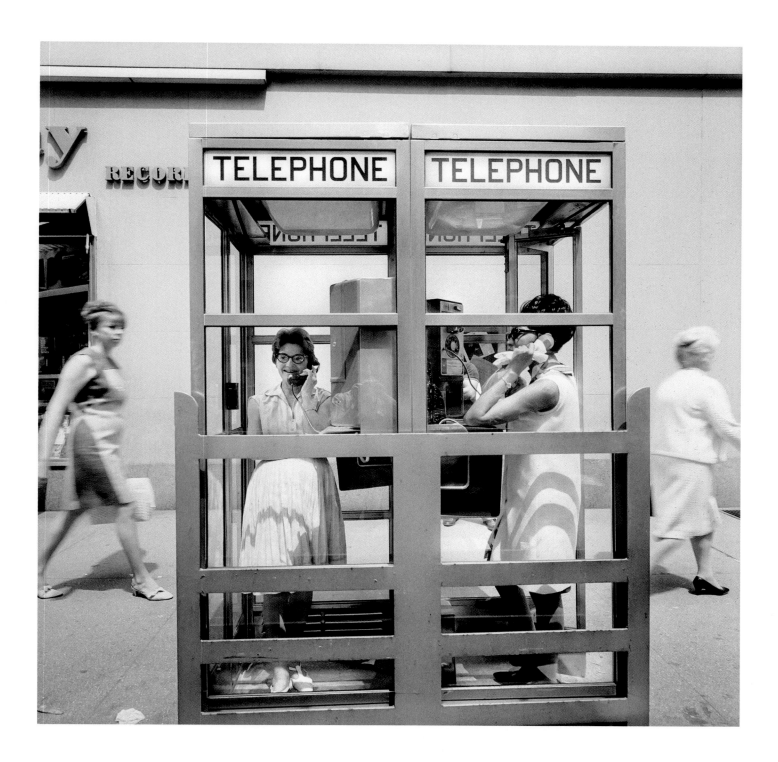

Telephone booths, New York, 1966

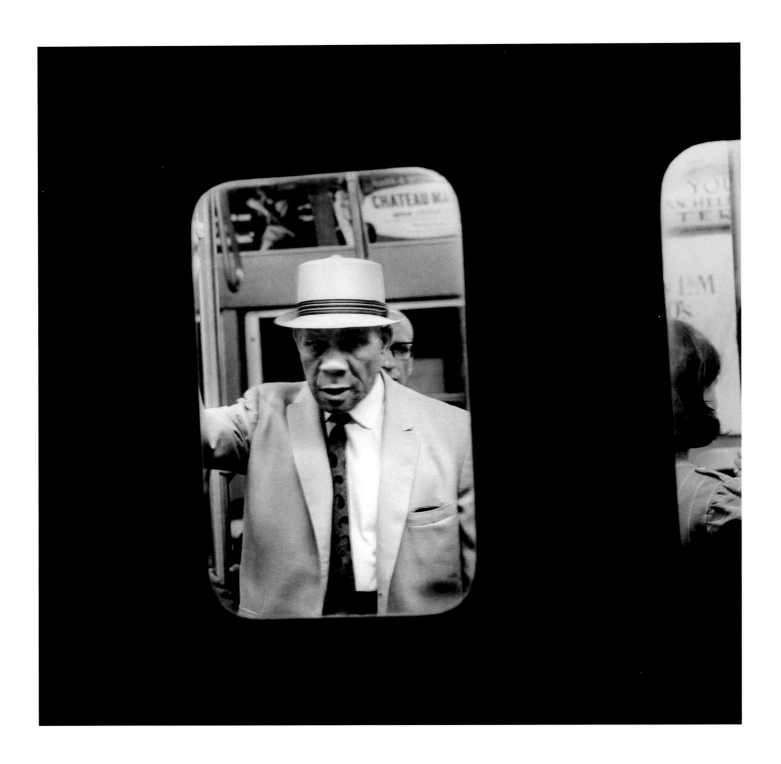

Subway, New York, 1967

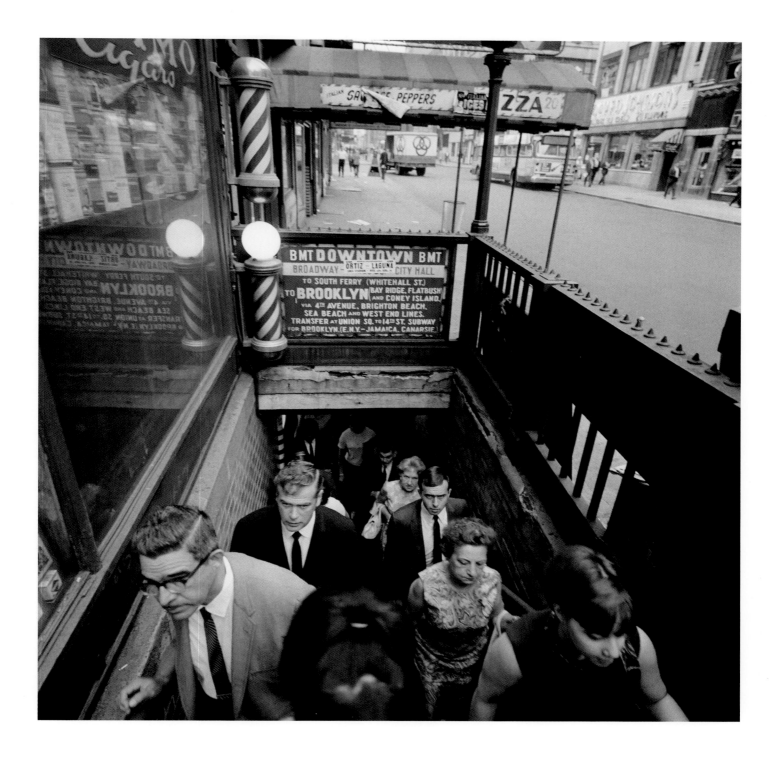

Subway entrance, New York, 1966

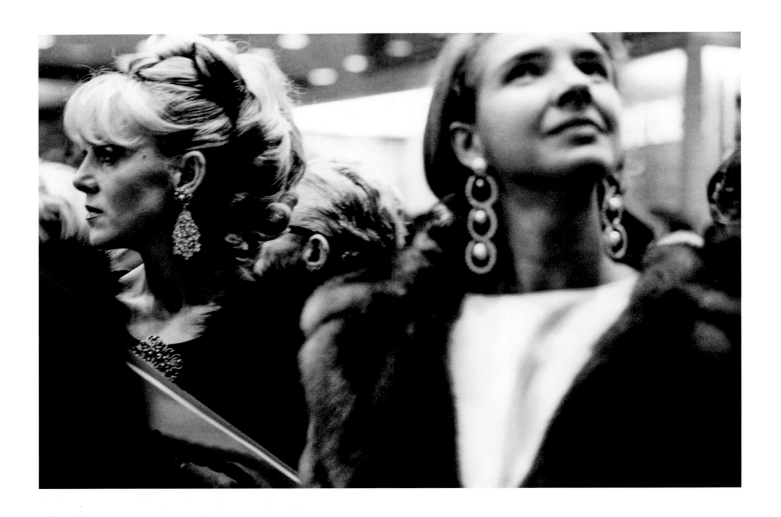

Ladies at movie premiere, Broadway, New York, 1966

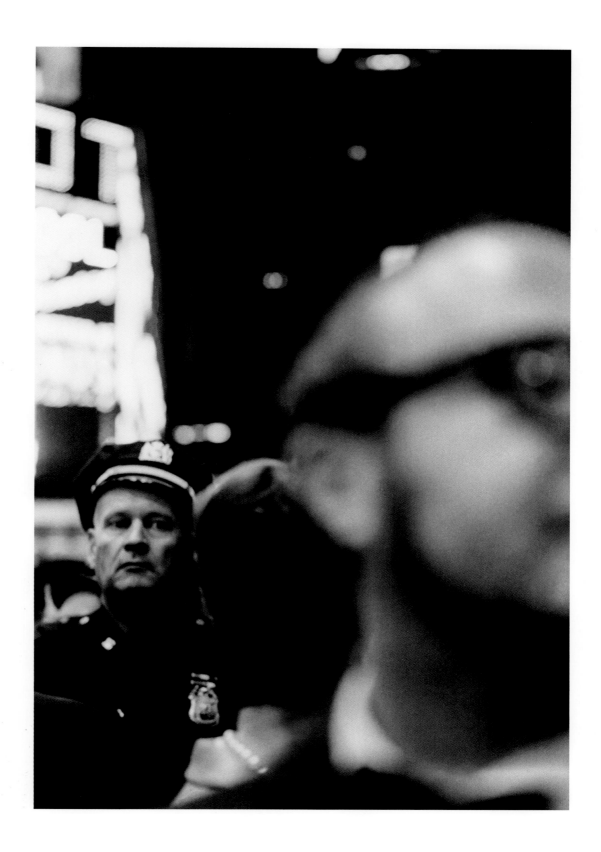

Movie premiere, Broadway, New York, 1966

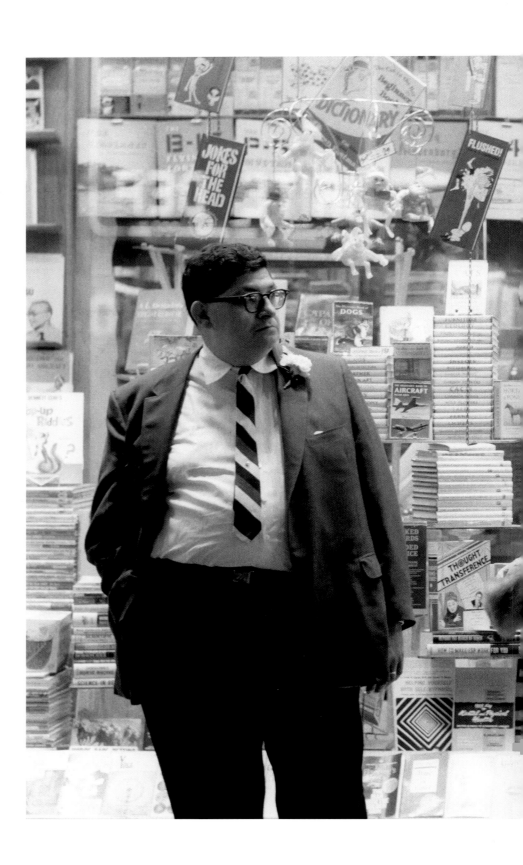

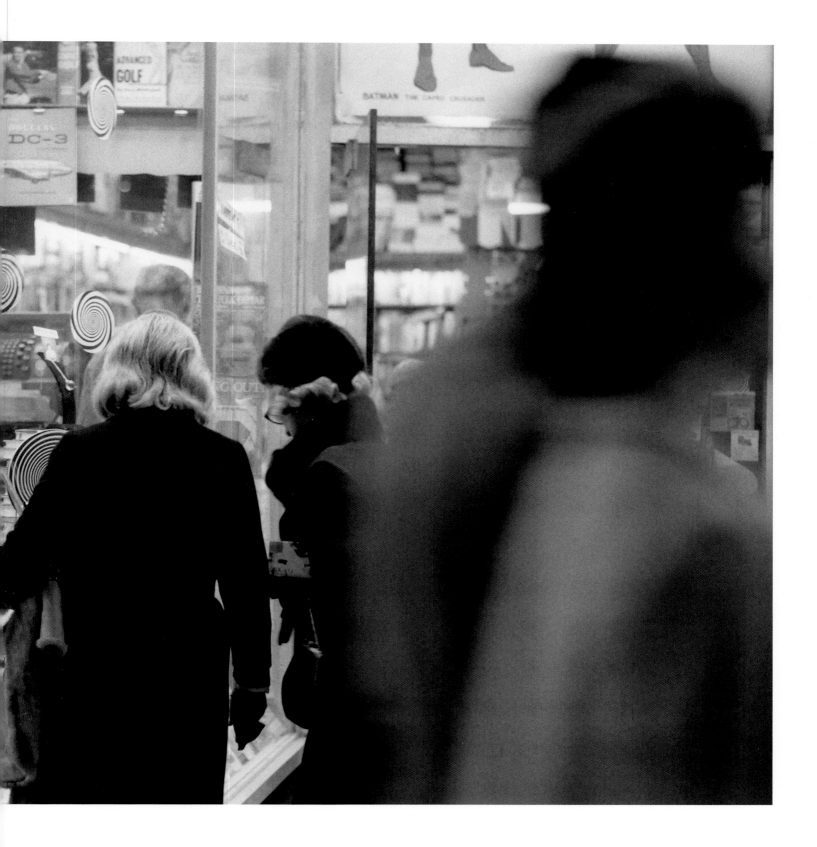

Blind date, New York, 1966

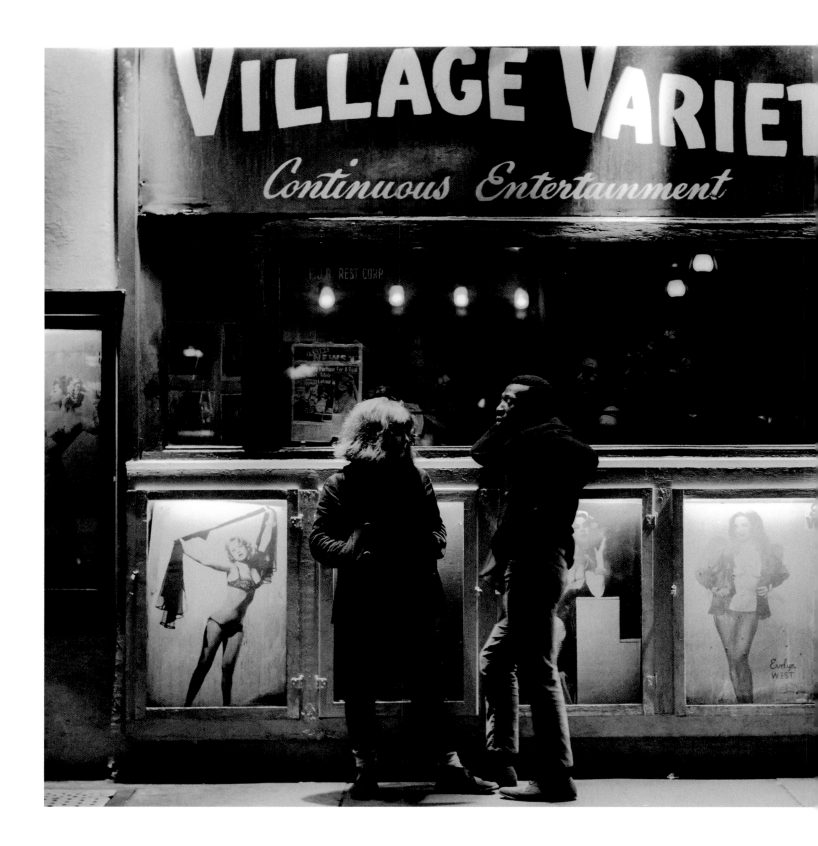

Village Varieties, New York, 1966

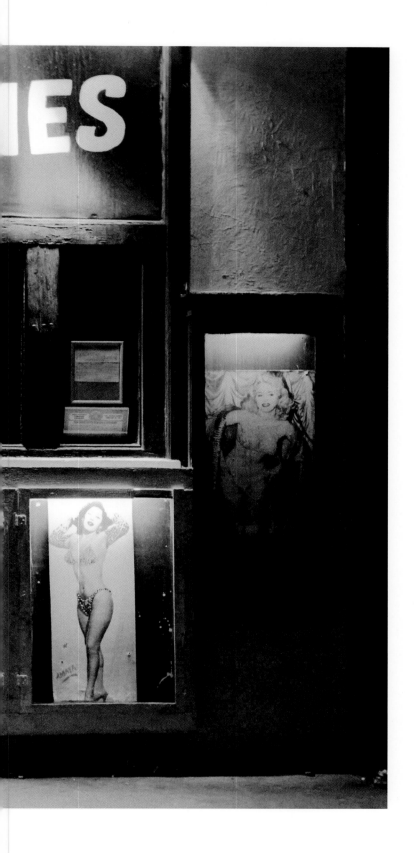

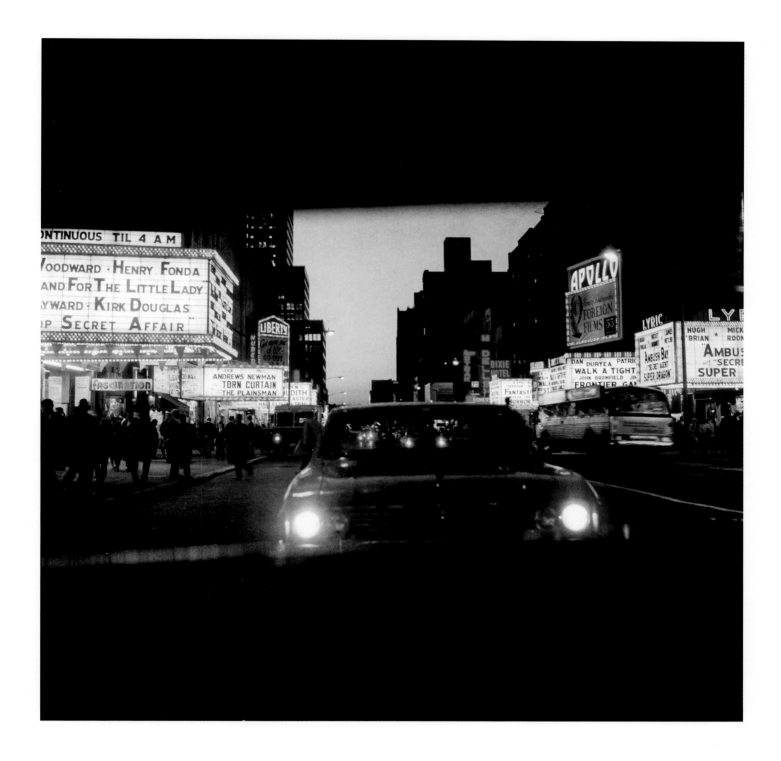

42nd Street at night, New York, 1966

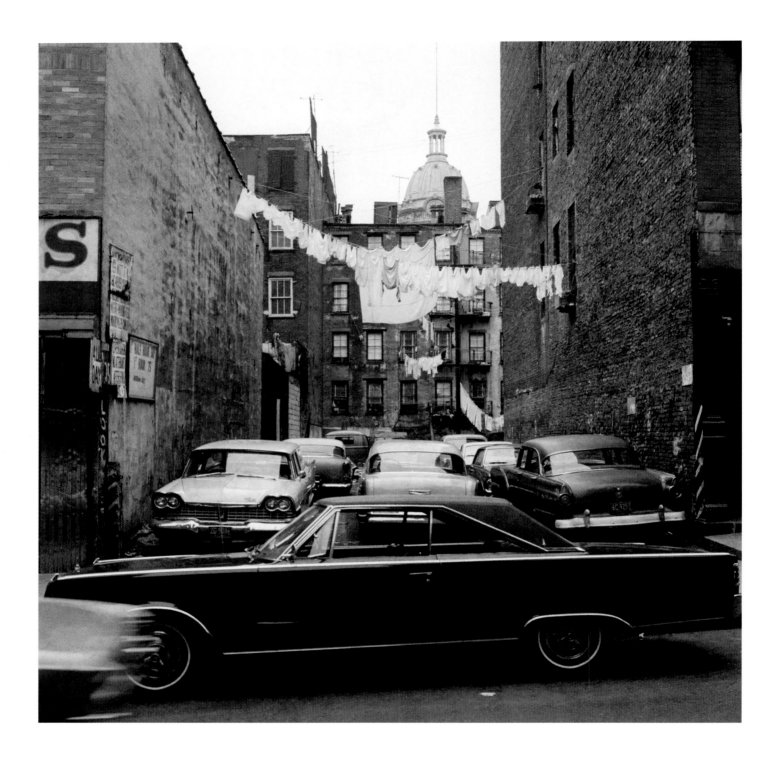

Black '67 Plymouth Belvedere, Brooklyn, New York, 1967

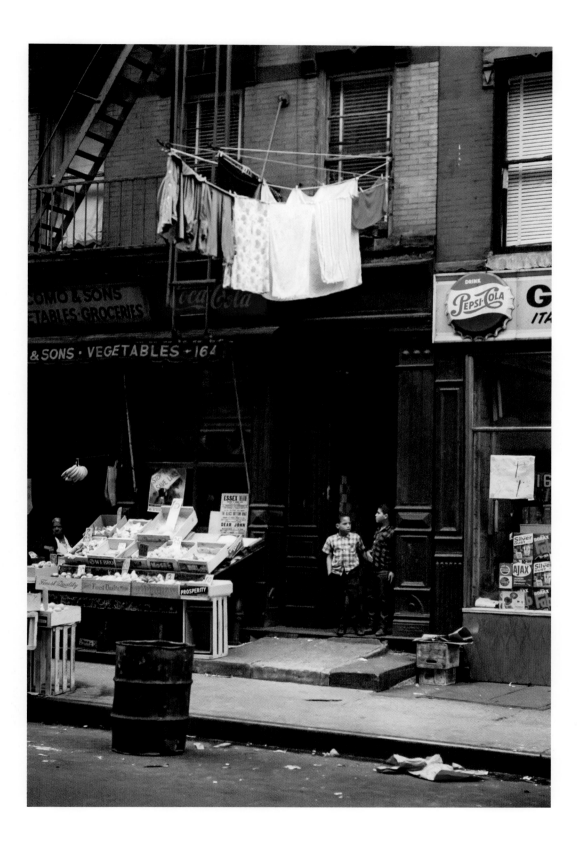

Grocery store, Brooklyn, New York, 1966

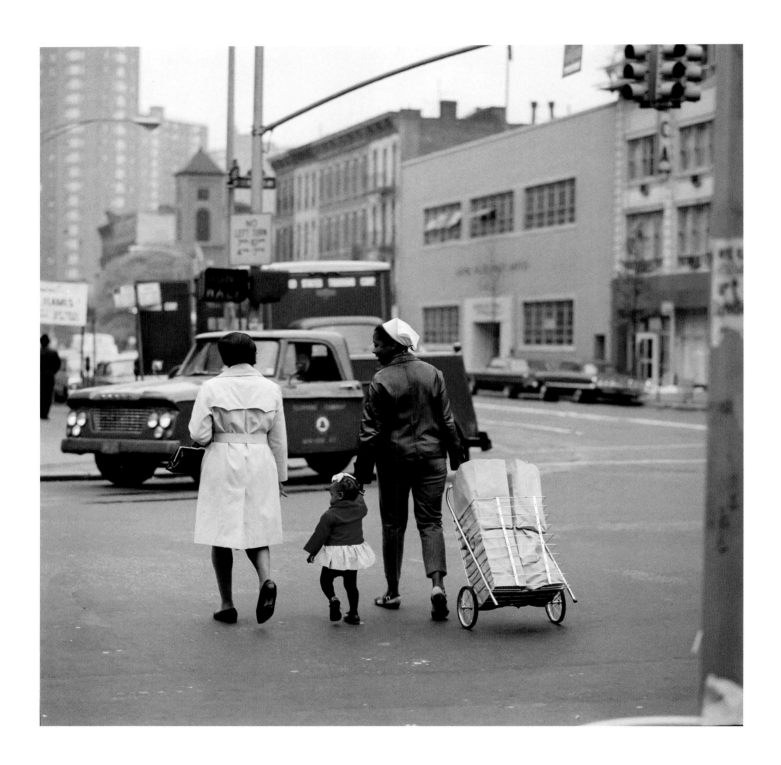

Grocery shopping, Harlem, New York, 1966

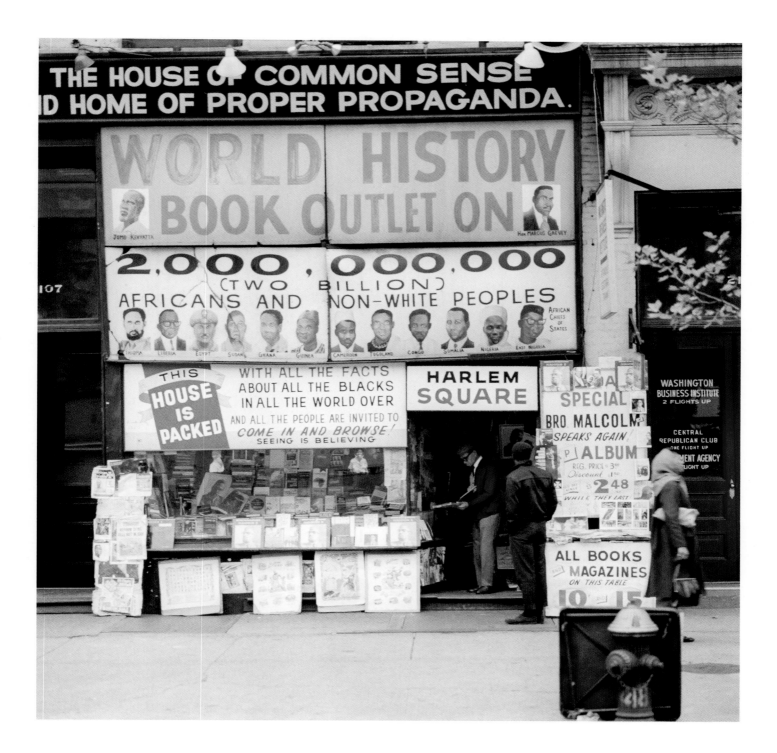

Nation of Islam bookstore, Harlem, New York, 1966

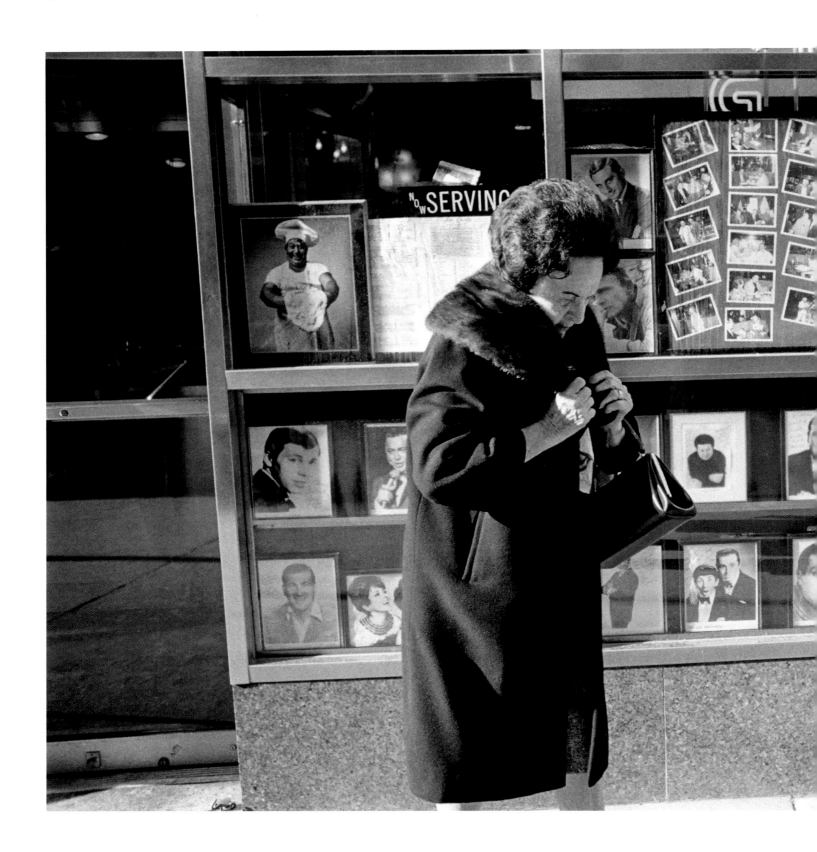

Lady in fur leaving pizzeria, New York, 1969

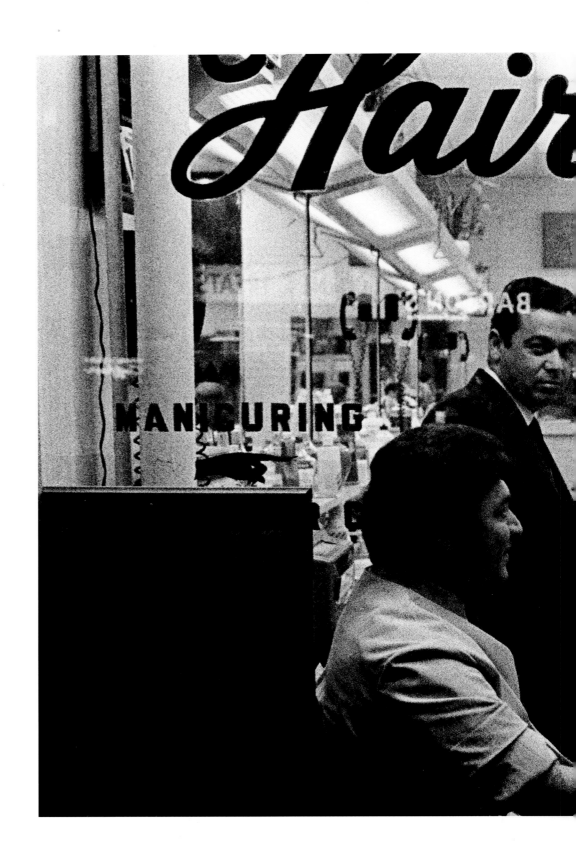

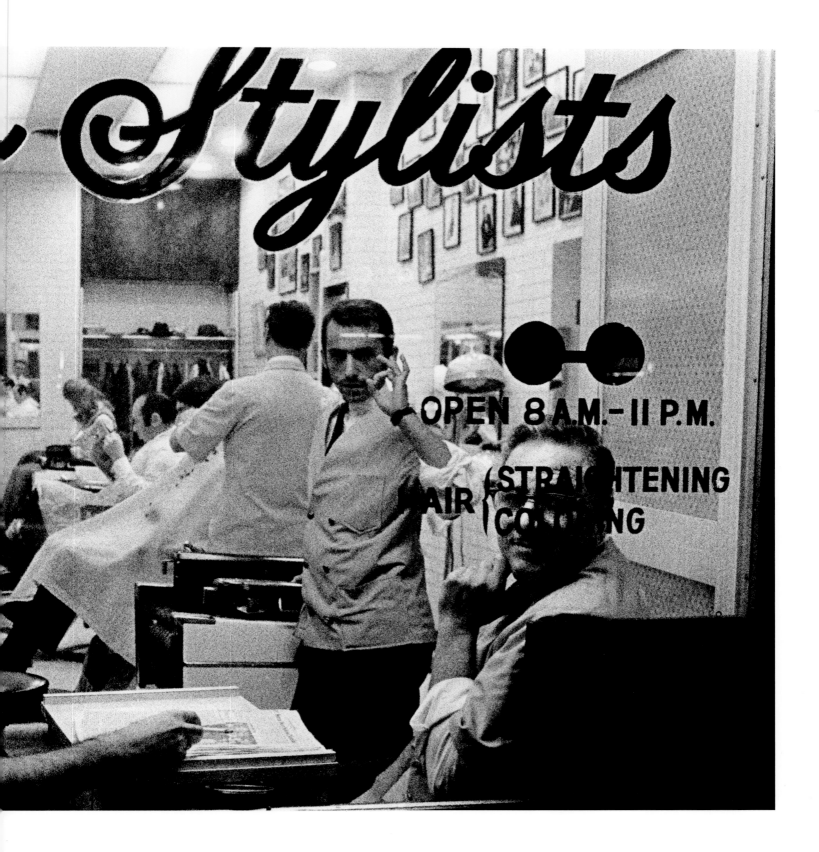

Hair stylists, New York, 1969

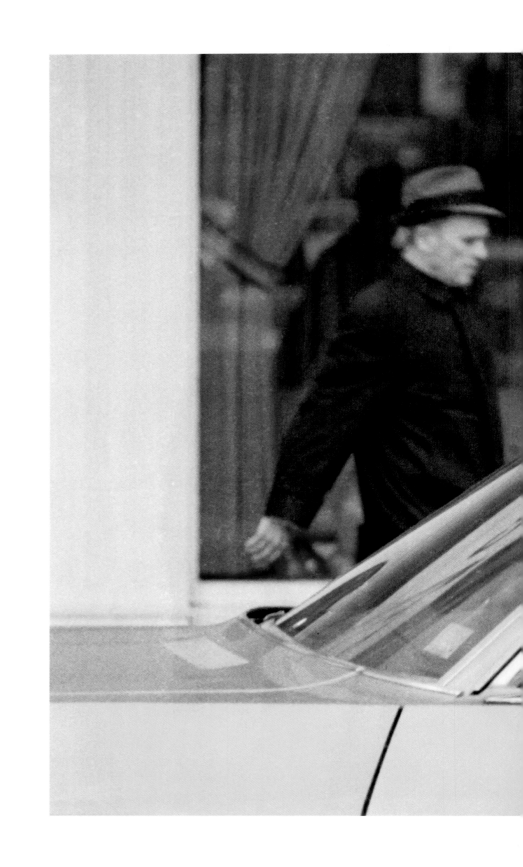

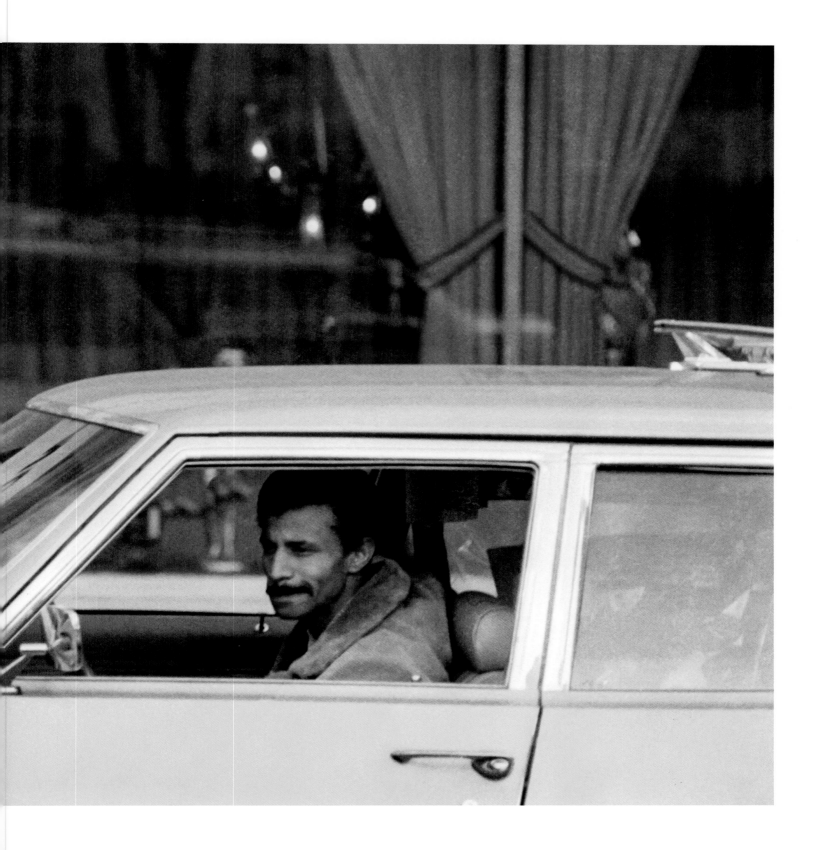

Man in a car window, New York, 1969

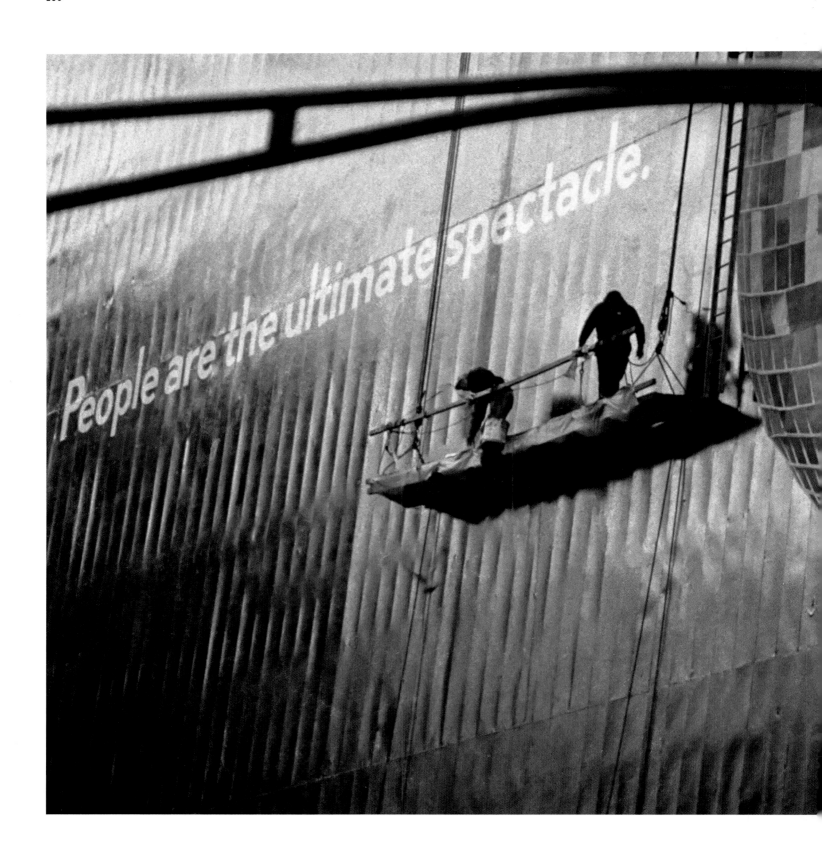

People are the ultimate spectacle, New York, 1969

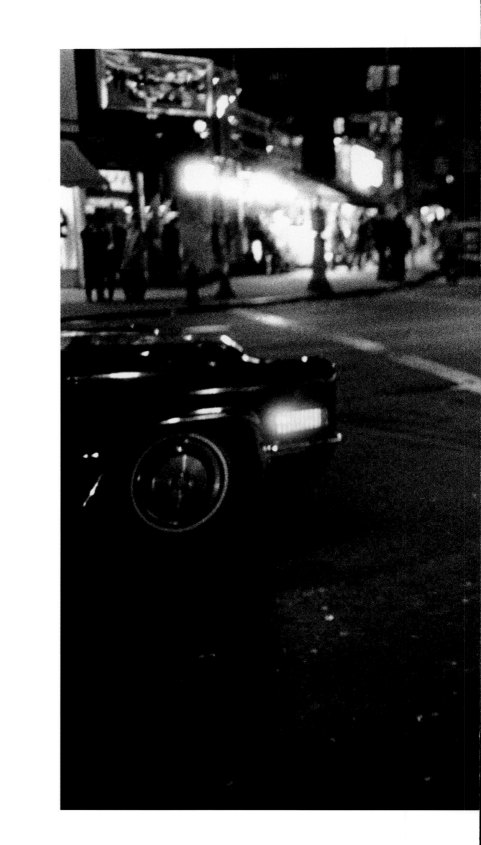

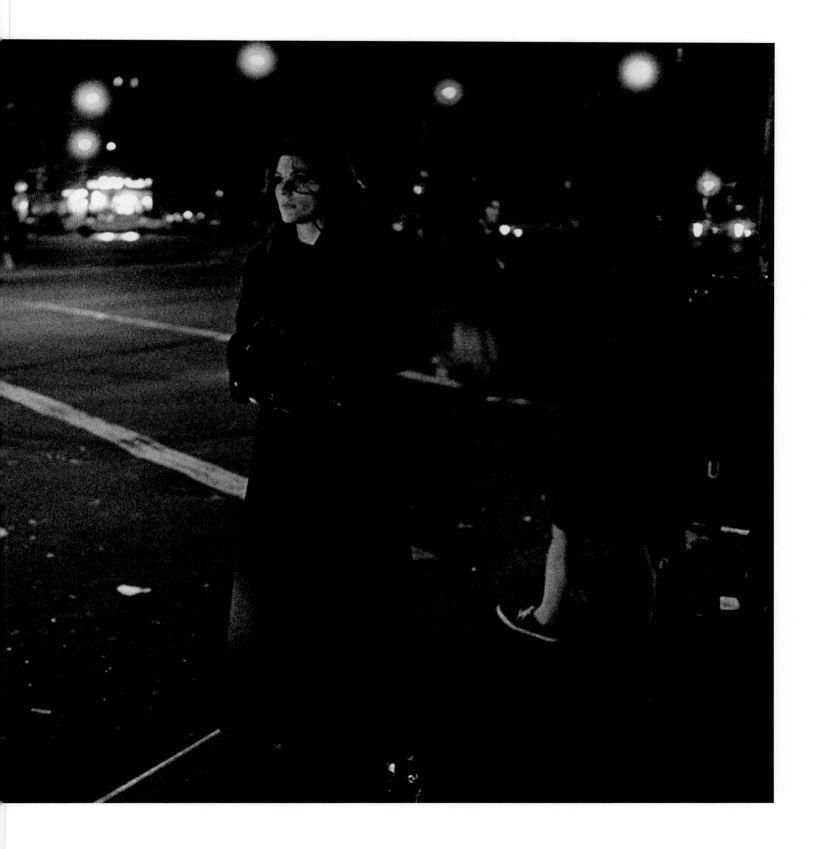

Street at night, Washington D.C., 1969

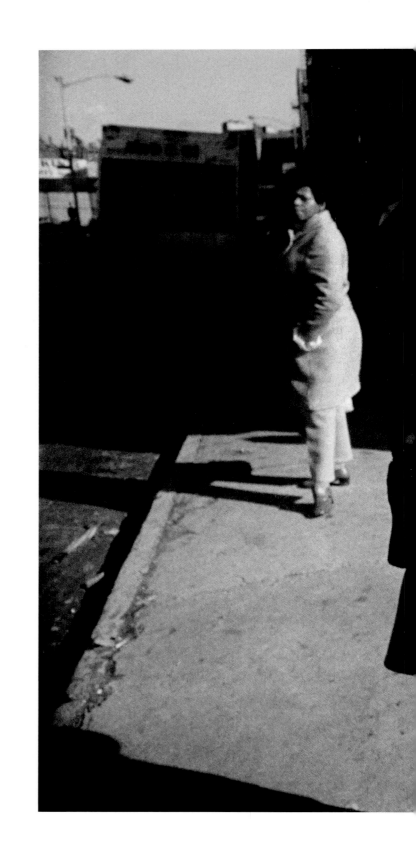

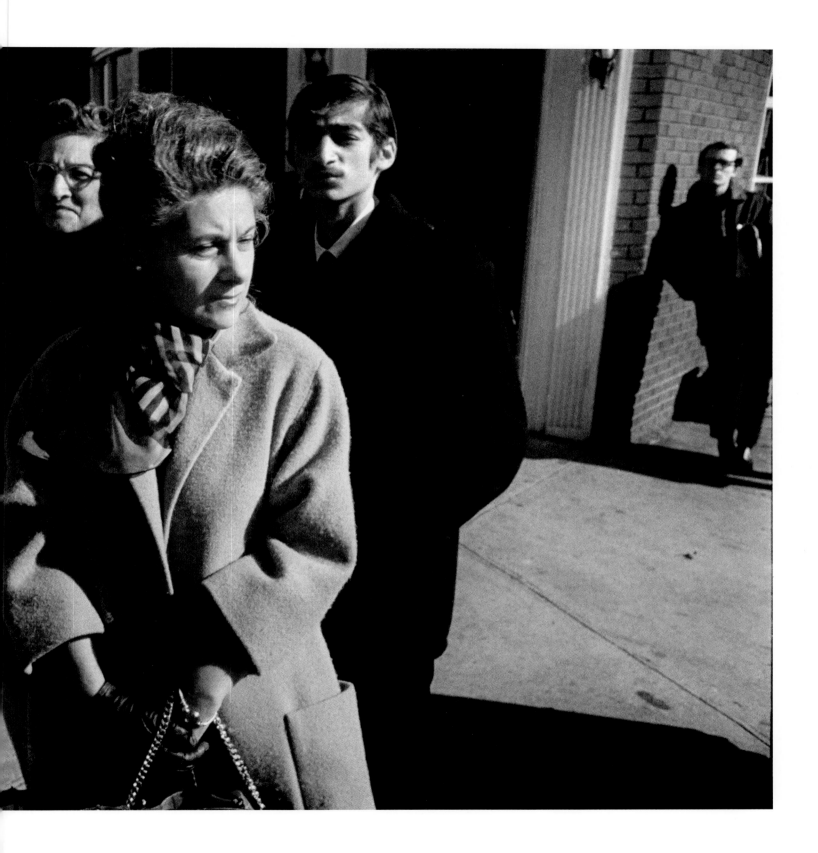

Aunt Edonide, Stanford, 1969

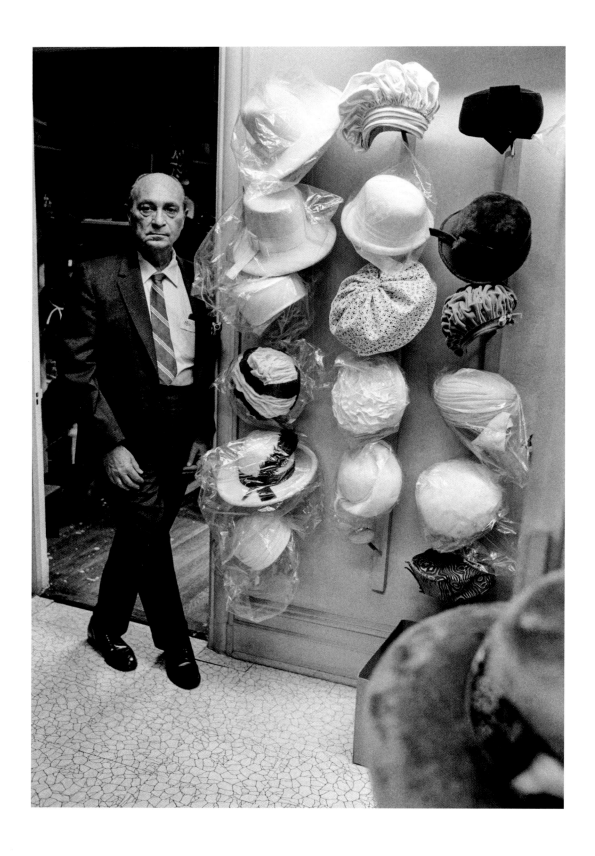

Hat seller, New York, 1969

I would first of all like to thank Tony Nourmand of Reel Art Press and David Hill of David Hill Gallery for making *American Voyage* possible.

Special thanks to the curator of my archive and my work Bärbel Reinhard and Marco Signorini for their help.

I also want to thank Luigina Murgia, Danilo Montanari, Samuele Bertinelli, Elena Testaferrata, Mariano Cipollini, Massimo Pantano, and Francesco Carnicelli.

in memory of Vincenzo and my parents.

David Hill Gallery would like to thank Alex Schneideman at Flow Photographic for his skillful work in bringing these wonderful images to life.

Captions for Opening Pages: p.2 Mario Carnicelli with construction workers, New York, 1966; p.5 Crowd watching television in shop window, New York, 1967; p.6 Airport barbershop, Chicago, 1966; p.9 Mario Carnicelli with Mamiya Universal 6x9 camera, New York, 1966; p.10 View from hotel window, Chicago, 1966; p.12 Mario Carnicelli with Hasselblad 500C camera, Dallas, 1967; p.14-15 Bus stop, Buffalo, 1966; p.16 double exposure, New York, 1966

Editors: Tony Nourmand and David Hill

Curator of the Mario Carnicelli Archive: Bärbel Reinhard

Consultant: Marco Signorini

Art Direction and Design: Joakim Olsson

Text Editor: Alison Elangasinghe

Editorial Assistant: Rory Bruton

First published 2018 by Reel Art Press/David Hill Gallery

Reel Art Press is an imprint of Rare Art Press Ltd., London, UK

www.reelartpress.com

First Edition

10 9 8 7 6 5 4 3 2 1

ISBN: 978-1-909526-57-0

Printed by Graphius, Gent